HOW TO READ

MEDIEVAL
ART

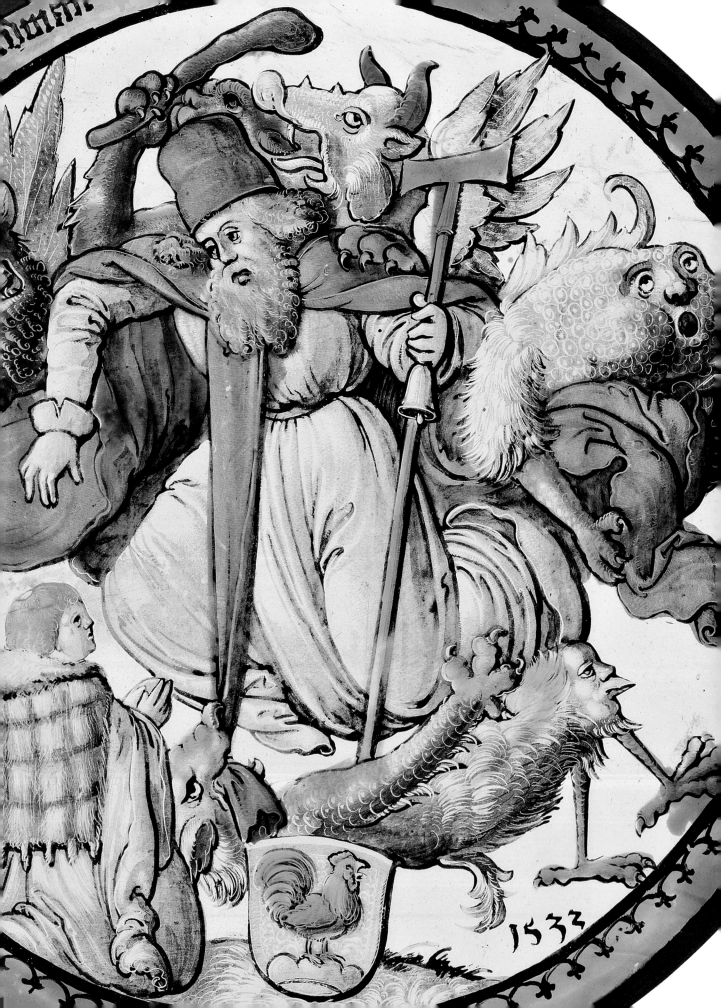

HOW TO READ
MEDIEVAL ART

Wendy A. Stein

THE
MET

The Metropolitan Museum of Art, New York
Distributed by Yale University Press, New Haven and London

This publication is made possible by the Mary C. and James W. Fosburgh Publications Fund, The Peter Jay Sharp Foundation, the Estate of Thomas Hoving, and The Levy Hermanos Foundation, Inc.

Published by The Metropolitan Museum of Art, New York
Mark Polizzotti, Publisher and Editor in Chief
Gwen Roginsky, Associate Publisher and General Manager
 of Publications
Peter Antony, Chief Production Manager
Michael Sittenfeld, Senior Managing Editor

Edited by Nancy E. Cohen
Designed by Rita Jules, Miko McGinty Inc.
Production by Lauren Knighton and Megan Kincaid

The works illustrated in this publication are in the collection of The Metropolitan Museum of Art, unless otherwise indicated. New photographs of works in the Metropolitan Museum's collection are by Peter Zeray, Imaging Department, The Metropolitan Museum of Art.

Additional photograph credit: figure 11, © The Bodleian Library, University of Oxford

Typeset in Documenta and Galliard
Printed on 150 gsm Creator Silk
Color separations, printing, and binding by Verona Libri,
 Verona, Italy

Cover illustrations: front, Workshop of Robert Campin, Annunciation Triptych (Merode Altarpiece) (detail), South Netherlandish, Tournai, ca. 1427–32 (entry 29); back, Casket with Scenes from Romances (detail), French, Paris, ca. 1310–30 (entry 35) Frontispieces: pages 2–3, Roundel with the Temptation of Saint Anthony, German, Swabia, 1532 (entry 20); page 6, Gil de Siloe, Saint James the Greater (detail), Spanish, Castile-León, 1489–93 (entry 18); page 8, Virgin and Child in Majesty (detail), French, Auvergne, ca. 1175–1200 (entry 22); pages 18–19, Tabernacle of Cherves (detail), French, Limoges, ca. 1220–30 (entry 3); pages 44–45, Master of the Barbo Missal, Mishneh Torah (fol. 205v), North Italian, ca. 1457 (entry 13); pages 64–65, Chasse of Champagnat, French, Limoges, ca. 1150 (entry 16); pages 86–87, Attributed to Lorenzo Monaco (Piero di Giovanni), *The Intercession of Christ and the Virgin* (detail), Italian, Tuscany, Florence, before 1402 (entry 28); pages 118–19, The Unicorn Purifies Water (detail), South Netherlandish, ca. 1495–1505 (entry 38); page 132, Plaque with Saint John the Evangelist, Carolingian, Germany, Aachen, early 9th century (fig. 14); page 134, Attributed to Claus de Werve, Virgin and Child (detail), French, Burgundy, Poligny, ca. 1415–17 (entry 26); page 136, Attributed to Jean de Touyl, Reliquary Shrine (detail), French, Paris, ca. 1325–50 (entry 1)

The Metropolitan Museum of Art
1000 Fifth Avenue
New York, New York 10028
metmuseum.org

Distributed by
Yale University Press, New Haven and London
yalebooks.com/art
yalebooks.co.uk

Library of Congress Cataloging-in-Publication Data

Names: Stein, Wendy Alpern, author. | Metropolitan Museum of Art (New York, N.Y.), issuing body.
Title: How to read Medieval art / Wendy A. Stein.
Other titles: How to read (Metropolitan Museum of Art (New York, N.Y.))
Description: New York: Metropolitan Museum of Art, [2016] | Series: How to read series | Includes bibliographical references.
Identifiers: LCCN 2016029568 | ISBN 9781588395979 (Metropolitan Museum of Art)
Subjects: LCSH: Art, Medieval.
Classification: LCC N5970 .S745 2016 | DDC 709.02/0747471—dc23
LC record available at https://lccn.loc.gov/2016029568

CONTENTS

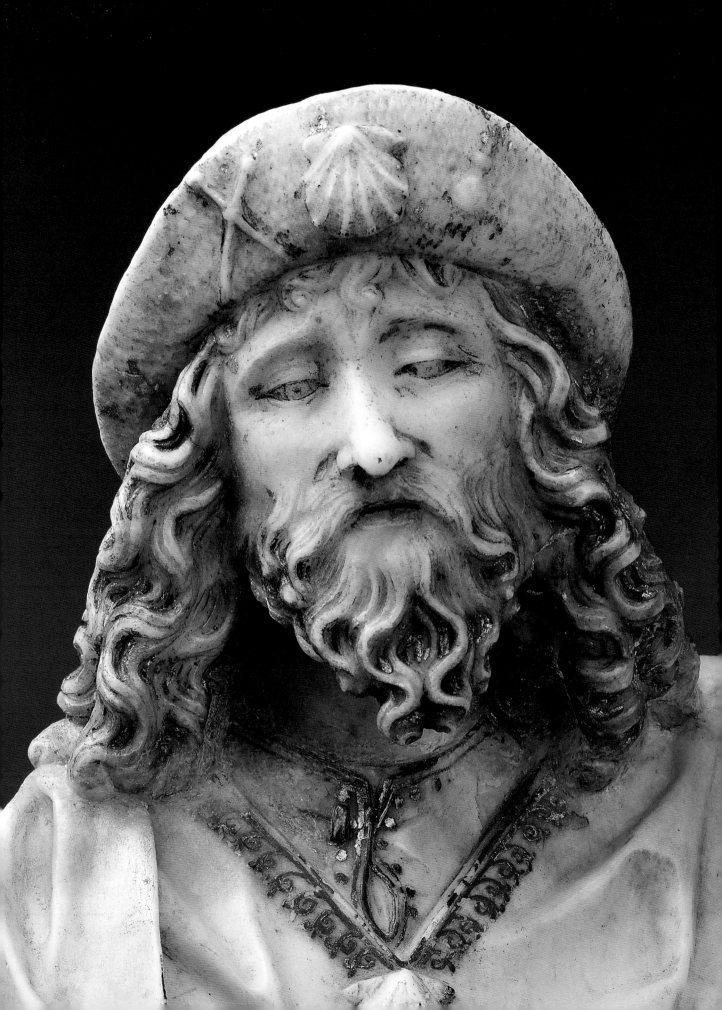

Director's Foreword

Manuscripts and icons glistening with gold, stained glass and enamels saturated with jewel-like colors, statues beautifully modeled from wood and stone: treasures of the Middle Ages fill The Metropolitan Museum of Art's galleries of medieval art in our main building on Fifth Avenue as well as our extraordinary landmark, The Met Cloisters, in Fort Tryon Park. Together the two venues constitute one of the world's most comprehensive collections of medieval art, spanning many centuries and ranging from the British Isles to Syria.

How to Read Medieval Art provides an easy entry point into the richness of these holdings. World-famous masterpieces such as the Unicorn Tapestries and the Merode Altarpiece appear in this book along with less familiar but no less fascinating works—some acquired within the last decade—providing a broad and vivid view of the art of the Middle Ages. The vibrant figures that fill these pages seize our imagination with their torments, their aspirations, and their transformative faith.

The author, Wendy A. Stein, focuses on the stories depicted in these works of art, many of them drawn from the Bible. To modern readers and museum visitors, the narratives of the Judeo-Christian tradition may be as unfamiliar as those of Egyptian gods, yet those narratives are fundamental to understanding medieval art. This book explores the iconographic themes that recur throughout art of the period so that they become clearly recognizable, and reveals how the differing representations of the subjects open vistas onto history and literature, faith and devotion.

Like other books in the How to Read series, this volume seeks to provide the general reader with a deeper understanding of a group of related objects and the era in which they were made. I hope it will inspire readers to visit the galleries on Fifth Avenue and at The Met Cloisters, and enhance their appreciation of medieval art in monuments and museums around the world.

We gratefully acknowledge the generosity of the Mary C. and James W. Fosburgh Publications Fund, The Peter Jay Sharp Foundation, the Estate of Thomas Hoving, and The Levy Hermanos Foundation, Inc., for making this publication possible.

Thomas P. Campbell

Director
The Metropolitan Museum of Art

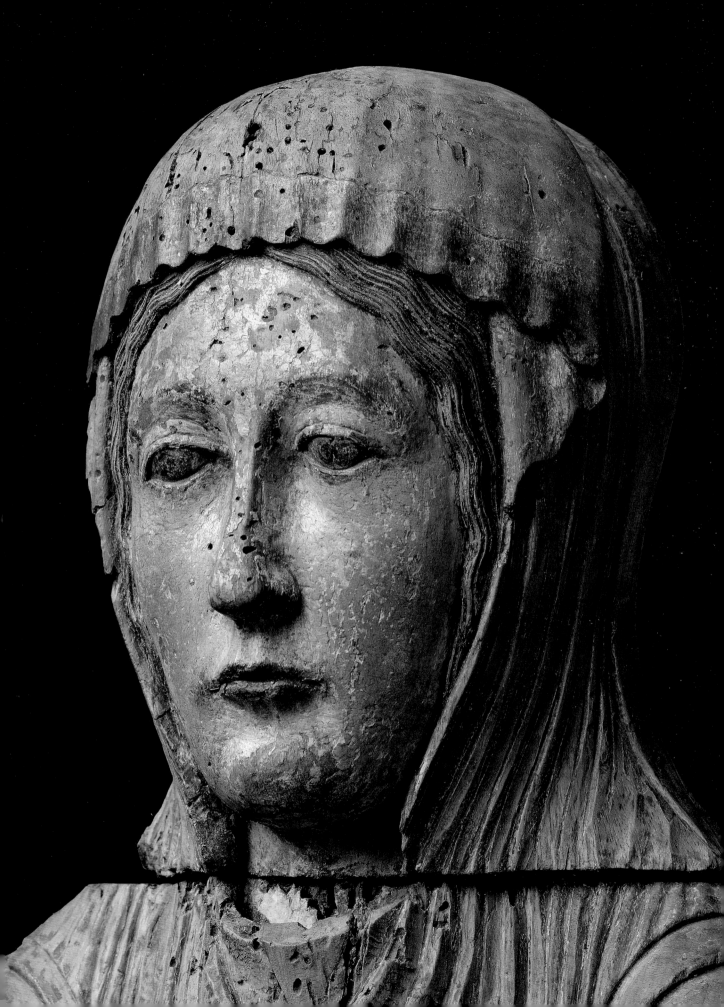

Introduction

The art of the Middle Ages is an art of storytelling. These works of glittering gold, brightly colored enamel, intricately carved ivory, and skillfully modeled wood and stone were all created to convey meaning. Although the art of the medieval world can be admired for its beauty, expressive intensity, and linear dynamism, understanding its narrative content is essential to experiencing its full resonance. The stories depicted, frequently drawn from the Bible and other religious literature, were universally known in their time but are often obscure today. Learning to recognize the most frequently shown subjects and characters (entries 1–3, 7, 14–20) and the visual signs and conventions used to represent them provides access to the art's deeper meaning and purpose. Understanding how these objects were regarded and used in their own time affords penetrating insights into the medieval world and an appreciation for the power of its art.

The Middle Ages spanned more than a millennium in a vast area ranging from the British Isles to Syria. Historical eras do not begin and end on precise dates, but the period is commonly defined as the interval between the ancient world and the Renaissance (roughly from the fifth to the fifteenth or sixteenth century). That tripartite view of history originated in fifteenth-century Italy, and the term "Middle Ages" gained currency in the seventeenth. The period can be said to have begun earlier, however, with the legalization of Christianity in the Roman Empire in the fourth century, and to have roots extending to the earliest centuries after Christ. Indeed, even older Celtic and Germanic traditions influenced the Middle Ages, as seen in medieval echoes of their non-representational, pattern-based art. The dynamic spirals of an ancient ring (fig. 1) exemplify curvilinear Celtic motifs and foreshadow the

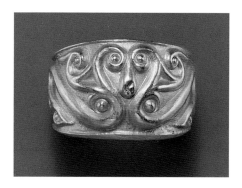

Figure 1. Ring. Celtic, 4th–5th century B.C. Gold, 1 x ⅝ in. (2.6 x 1.6 cm). Gift of Josef and Brigitte Hatzenbuehler, 2009 (2009.532.3)

animated whorls of the abstracted drapery in a manuscript illumination made more than a thousand years later (fig. 2).

The art and culture of the Middle Ages emerged from that of those and other migrating "barbarian" tribes and from the Greco-Roman traditions established across the wide expanse of the Roman Empire, which encircled the Mediterranean Sea. The empire had been pagan, but in the fourth century Constantine the Great (ruled 306–37) adopted and legalized Christianity and moved the capital east, from Rome to the city then called Byzantion, which he renamed Constantinople. As Christianity developed and spread, both Constantinople (present-day

Figure 2. Christ in Majesty with Angels (detail), Leaf from a Beatus Manuscript. Spanish, Castile-León, Burgos, ca. 1180. Tempera, gold, and ink on parchment, folio overall 17½ x 11⅞ in. (44.4 x 30 cm). Purchase, The Cloisters Collection, Rogers and Harris Brisbane Dick Funds, and Joseph Pulitzer Bequest, 1991 (1991.232.3)

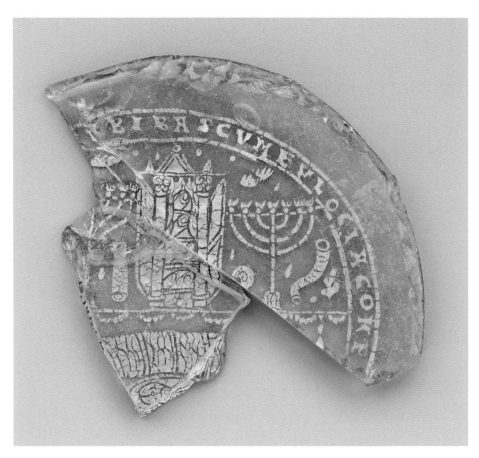

Figure 3. Bowl Fragments with Menorah, Shofar, and Torah Ark. Roman, 300–350. Glass and gold leaf, 2⅝ x 2¾ x ¼ in. (6.9 x 7 x 0.7 cm). Rogers Fund, 1918 (18.145.1a, b)

Istanbul) and Rome flourished as major Christian bishoprics, drawing from a shared history and faith. By the ninth century, however, distinctions in doctrine and liturgical protocols had emerged, separating the Orthodox Church centered in Constantinople from the Latin Church centered in Rome. The commonalities and gradual divergence were political and cultural as well as religious. Constantinople, also called New Rome, ruled an empire that saw itself as the true descendant of the ancient Roman Empire. After the loss of western provinces to invading Germanic and other tribes in the fifth century, and the loss of African and eastern provinces with the seventh-century rise of Islam, the extent of what came to be called the Byzantine Empire was reduced to an area approximating modern Greece, much of the Balkans, and Turkey.

During the medieval era, followers of the Jewish religion coexisted with Orthodox and western Christians as well as with Muslims, though they were always a minority population. Jewish characters and stories drawn from the Hebrew Bible frequently appear in medieval art made for Christian patrons (entries 8–12), but Jews themselves were often persecuted, and art made for them is notably underrepresented in surviving material culture. Two objects must suffice here to represent their patronage in the Middle Ages, a beautiful manuscript from the end of the period (entry 13) and, from a much earlier time, a small, broken, but important object (fig. 3).

This glass fragment, formerly the base of a drinking bowl, conveys volumes about both the wealth and status of Jews and the cultural and religious cross-currents in the later Roman Empire. Circular glass objects with designs in gold leaf sandwiched between two layers of glass are well known from that time. Manufactured with an intricate technique and of an intrinsically valuable material, they signal their patrons' prosperity. Gold glasses are most commonly found with pagan or Christian iconography; this rare example depicts a full range of Jewish liturgical objects, including two menorahs (candelabras),

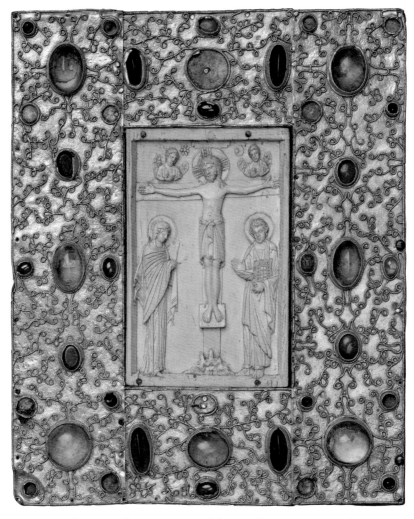

Figure 4. Book Cover with Byzantine Icon of the Crucifixion. Cover: Spanish, Jaca, before 1085; icon: Byzantine, Constantinople, 1000. Gilded silver with pseudo-filigree, glass, crystal, and sapphire cabochons, ivory on wood support, 10⅜ x 8⅝ x 1 in. (26.4 x 21.9 x 2.5 cm). Gift of J. Pierpont Morgan, 1917 (17.190.134)

a Torah ark with scrolls inside, and a shofar (ram's horn). This precious piece of glass testifies to the proximity of and exchange among Jews, pagans, and Christians, who were all employing the same pool of artists and artisans to manufacture similar objects with identical technique. Likewise the Mishneh Torah (entry 13) provides evidence of an artist working in both the Jewish and Christian communities at the end of the Middle Ages.

Cross-cultural exchanges also continued between the art of the Eastern and Western churches, even as their congregations and artistic traditions diverged. Trade, diplomatic gifts, mendicant preaching orders, and pilgrimage (see entry 18) helped disseminate objects across the continent throughout the period. In addition, starting in the late eleventh century, crusaders from western Europe traveled to the Holy Land to win Jerusalem from Islam and came home with Byzantine icons (see entry 6) and relics. Through many such channels, the art that had developed in the Byzantine East spread to the Latin West and came to influence western European imagery. Byzantine pieces were incorporated into objects made in western Europe, such as the ivory icon embedded in the center of a liturgical book cover (fig. 4). Western artists also adopted Byzantine figural conventions, as can be seen in an affectionate Virgin and Child (fig. 5) based on the Eleousa, one of the Orthodox representations of Mary (see entry 27).

In both the Byzantine East and the Latin West, the art of the Middle Ages was not made by artists concerned with personal expression. It was made because patrons caused it to be made, in many cases specifying the details

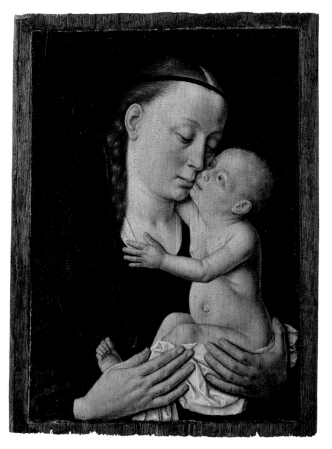

Figure 5. Dieric Bouts (Netherlandish, active by 1457–died 1475). Virgin and Child. Netherlandish, ca. 1455–60. Oil on wood, 8½ x 6½ in. (21.6 x 16.5 cm). Theodore M. Davis Collection, Bequest of Theodore M. Davis, 1915 (30.95.280)

Figure 6. Jean Pucelle (French, active Paris 1319–34). The Annunciation (detail of fol. 16r), The Hours of Jeanne d'Evreux, Queen of France. French, Paris, ca. 1324–28. Grisaille, tempera, and ink on vellum, folio overall 3⅝ x 2½ in. (9.2 x 6.2 cm). The Cloisters Collection, 1954 (54.1.2)

the artist should include. Art was created at the behest of people and institutions of power and wealth. In the early centuries of the period, the majority of items in all media were produced for the monastery or church: chalices for use in the service, book covers for liturgical manuscripts, and works made to adorn ecclesiastical architecture. Kings, queens, and other aristocrats also had the means to order art and architecture to their specifications. In the later Middle Ages, individual patrons became more numerous, extending beyond royalty into the higher nobility and even to the newly wealthy classes of townspeople (see the donor portraits in entry 29).

The artist crafting a commissioned piece did not create a wholly new vision of the subject but rather based the work on the long history of representations of a given

scene or character. But even though medieval art draws upon a consistent set of subjects and well-established conventions, the results are wonderfully diverse. While certain elements were essential to a subject's depiction, stories could be embellished with additional details taken from a familiar repertoire. The Annunciation (entries 1, 29), for example, always includes the Archangel Gabriel and the Virgin, but they are often joined by a dove representing the Holy Spirit (who arrives through an opening in the ceiling in fig. 6). Representations were also modified by artistic capacity and invention and by patrons' special concerns, as well as by period and local style, as seen in two treatments of the Throne of Wisdom type of the Virgin in Majesty. Made only a few decades apart in France, one in Burgundy (fig. 7) and the other in

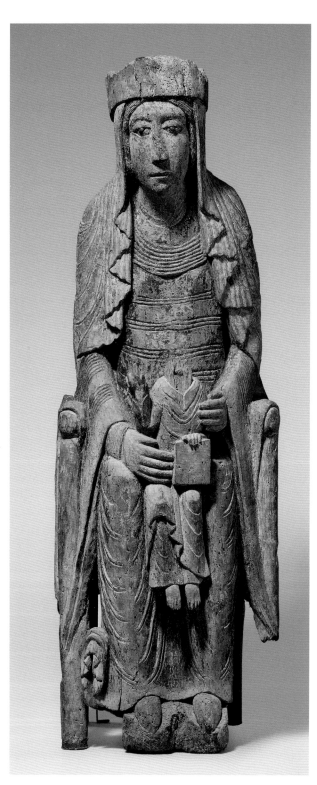

the Auvergne (entry 22), they project different personalities. The slightly elongated figure and face of the Burgundian Mary accord with her gently sorrowful expression, a contrast to the Auvergne Virgin's stoic steadfastness. Their distinct local styles emerge especially in the rendering of drapery, with flattened zigzags and incised ridges in the former and rhythmic curves in the latter.

Notwithstanding variations in style, the taste of the age tends to glitter, color, and shiny materials, as exemplified by the dazzling Reliquary Shrine (entry 1). Made of gilded silver and enamel in highly saturated colors, its reflective surfaces would have been further enlivened by candlelight. Stained glass, painted statues, and brilliant golden and silver vessels (fig. 8), sometimes inlaid with gemstones, awed the worshipers who saw them in church and appealed to the sensibility of the wealthy who commissioned them for private devotion. But the taste for luminosity has deeper meaning and associations. The preciousness of gems, gold, and silver is meant to convey the object's power and to honor that which is represented.

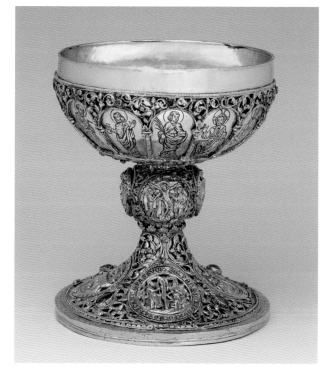

Figure 7. Enthroned Virgin and Child. French, Burgundy, ca. 1130–40. Birch with paint and glass, H. 40½ in. (102.9 cm). The Cloisters Collection, 1947 (47.101.15)

Figure 8. Chalice. German, Upper Rhineland, ca. 1230–50. Silver, gilded silver, niello, and jewels, 8 x 6⅞ in. (20.3 x 17.5 cm). The Cloisters Collection, 1947 (47.101.26)

Likewise, reliquaries glorify the sacred remains they contain with costly materials and skilled workmanship (see entry 16); they sometimes take the form of body parts, as does this arm reliquary (fig. 9), perhaps to associate the object more vividly with the saint whose bone fragment lies within.

The brilliant surfaces were also imbued with a more abstract theological resonance. Abbot Suger of Saint Denis (1081–1151) was only the most famous of the many churchmen who preached brightness as a metaphor for divine light, and advocated for its use in material things to lead the mind to the immaterial light of the divine. When medieval poets describe the Heavenly Jerusalem as a jeweled and golden city, they recall the Book of Revelation: "Jerusalem . . . shone with the glory of God, and its brilliance was like that of a very precious jewel, like a jasper, clear as crystal."

The art of the Middle Ages also reflected the evolution of devotional practice over the centuries, which can generally be described as a shift from ritual observance dictated by and practiced in the institutional church and monastery to more individual worship, and from viewing Christ as a distant divinity to seeing Jesus as human. Those changes and the associated preaching that urged the faithful to empathize with Mary and her son contributed to the increasingly emotional tenor of medieval art, which can be read in the formal qualities of images of the Virgin (entries 22–29) and Crucifixion (entries 30–33). The church's encouragement of a more personal form of worship extended to granting permission to individuals to take up some of the practices once reserved for the clergy. The monastic liturgical tradition of reciting a set of prayers at eight canonical hours of each day was adopted in the later Middle Ages by literate laypeople, giving rise to a new type of manuscript, the Book of Hours (see entries 5, 19). Used by wealthy and even middle-class readers for their private prayers, the Book of Hours was the most popular type of book from the fourteenth through the fifteenth century. These devotional manuscripts all include a particular set of prayers variously augmented with other texts, and were often customized for the client with the addition of decoration, from a few highlighted initials to many lavish illuminations.

The Power and Purpose of Medieval Art

Both Judaism and Christianity are religions of the Book, and teaching biblical narratives, including through visual means, is central to their practice. Biblical scenes and characters recur frequently in the art of the period, distilled to readily recognizable components that enabled them to communicate powerfully. Through repetition, these motifs, poses, and iconography became a familiar shorthand that allowed the stories in their many manifestations to be easily "read." Of course, images tell stories differently from words; they not only illustrate and interpret the text, they inform the reader's mental image,

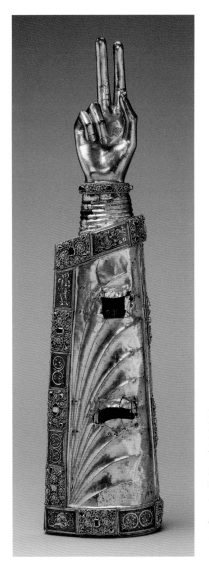

Figure 9. Arm Reliquary. South Netherlandish, Meuse Valley, ca. 1230. Silver, gilded silver, niello, and gems, wood core, 25½ x 6½ x 4 in. (64.8 x 16.5 x 10.2 cm). The Cloisters Collection, 1947 (47.101.33)

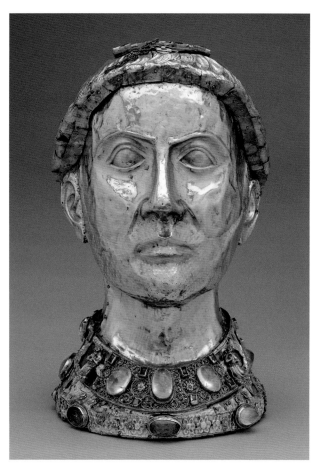

Figure 10. Reliquary Bust of Saint Yrieix. French, Limoges, ca. 1220–40, with later grill. Silver and gilded silver with rock crystal, gems, and glass, 15 x 9¼ x 10¼ in. (38.1 x 23.4 x 26.1 cm). Gift of J. Pierpont Morgan, 1917 (17.190.352a)

assertion that images were not idolatrous and could be important tools in religious practice became a fundamental argument for allowing them.

The permissibility of images has been repeatedly contested throughout the history of all three monotheistic religions, with recurring periods of iconoclasm. Christianity had inherited from Judaism the Ten Commandments of the Old Testament, including the prohibition against figural representation; the underlying concern was that the images themselves would be worshiped, as were pagan idols. The debate raged for centuries in the early church, culminating, within the sphere of the Byzantine Empire, in the Iconoclastic Controversy. From 726 to 787, figural imagery was banned, and only the cross, an abstract image, was permitted in churches. Hundreds of works of art were destroyed, plastered over, or defaced. In 787, the Second Council of Nicaea set forth a clear statement of doctrine favoring the veneration (as distinct from the adoration) of images (see entries 6, 32). However, a second period of iconoclasm began with the accession of a new emperor in 814. Only in 843, with another change in power, was icon veneration restored. From that time on, Orthodox practice recognized that the honor given to images passed on to the prototype in heaven. Both sides of the controversy underscore the awesome power ascribed to art, whether it was feared as seductively idolatrous or revered as a devotional tool.

Most art of the period served that powerful purpose. None of it was made "for art's sake," not even the secular art (entries 34–38). Every work had a function, not just containers and vessels (entries 35, 36) and objects with a specific use in liturgy or other ceremonial context (entries 3, 4), but each painting and carving. An object depicting a sacred scene had an active role in religious practice. It had many purposes: to recall to the viewer a larger story; to provide the believer with guidance; to embody and exalt that which is holy; to link the past with the present; to connect the worshiper to heaven. The powerful function of art, moreover, did not only inhere in the object; it also depended upon the direct involvement of the viewer. The intense gaze of an icon or reliquary head (fig. 10) was returned by the worshiper's passionate contemplation. This art was made in expectation of a profound relationship between the object and the observer.

fleshing out the kings of the Hebrew Bible (entry 10), the disciples in the Gospels (entries 17, 18), and the saints in the liturgy (entries 19–21) as vibrant characters. The concept of reading art played a crucial part in developing Christianity and echoed through the centuries. An early pope, Saint Gregory the Great (ca. 540–604), wrote of art's important didactic role in about 600: "To adore images is one thing; to teach with their help what should be adored is another. What Scripture is to the educated, images are to the ignorant . . . who read in them what they cannot read in books." While Gregory's statement can be difficult to interpret precisely and does not address the fact that much medieval art was made for a literate audience, such as the clergy and educated noble classes, his

Art in the Middle Ages had agency; as a conduit to the sacred person represented, it was deemed able not only to listen to a supplicant's prayers (see entry 22) but also to win battles and cure illness. As a stand-in on earth for its prototype in heaven, an image of a saint or of the Virgin Mary would be treated as a person in its own right, honored with gifts and carried reverently through a town or from altar to altar within a church. Harming an image was considered an offense to the holy person represented, just as desecrating the flag is illegal in our own time. In the Orthodox Church, certain icons were understood to be palladia, protectors of a specific locale or city. The theologically sanctioned uses for images were at times exceeded in the popular imagination to foster legends about their miracle-working capacity. Medieval manuscripts in Ireland were scraped to make potions to cure the illness of cattle. Statues of the Virgin and Child inspired an entire genre of miracle stories about images that could bleed, speak, turn pale, weep, or even lactate, as in a legend concerning the great twelfth-century theologian and saint, Bernard of Clairvaux. It was said that when Bernard, reciting a hymn while fervently praying before a statue of the Virgin, intoned the words "show me you are mother," the statue issued a stream of milk into the saint's mouth. The miracle legend enjoyed wide circulation and was frequently depicted visually (fig. 11), evidence of contemporary belief in art's exalted potency.

For this is unquestionably an art of power. The intensity with which it was regarded at the time of its creation is hard to imagine today, yet medieval art has universal resonance. We do not have to be Christian to respond to images of the Virgin and Child or Christ's Passion, to be touched by a mother's joys and sorrows or to empathize with the pain suffered by an innocent man. When the intensity of a figure's gaze compels us to draw near, we sense the power that those eyes held for the medieval viewer, a power that links us, human to human, across a gulf of time.

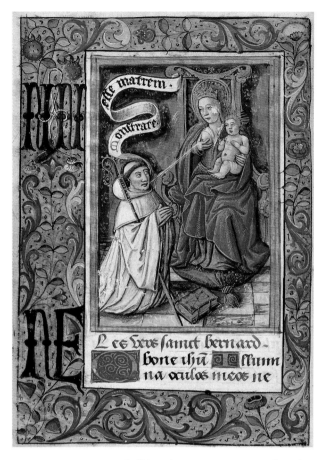

Figure 11. Lactation Miracle (fol. 38v), MS Douce 264. French, early 16th century. Tempera, gold, and ink on parchment, 7½ x 5⅛ in. (18.9 x 13 cm). The Bodleian Library, University of Oxford

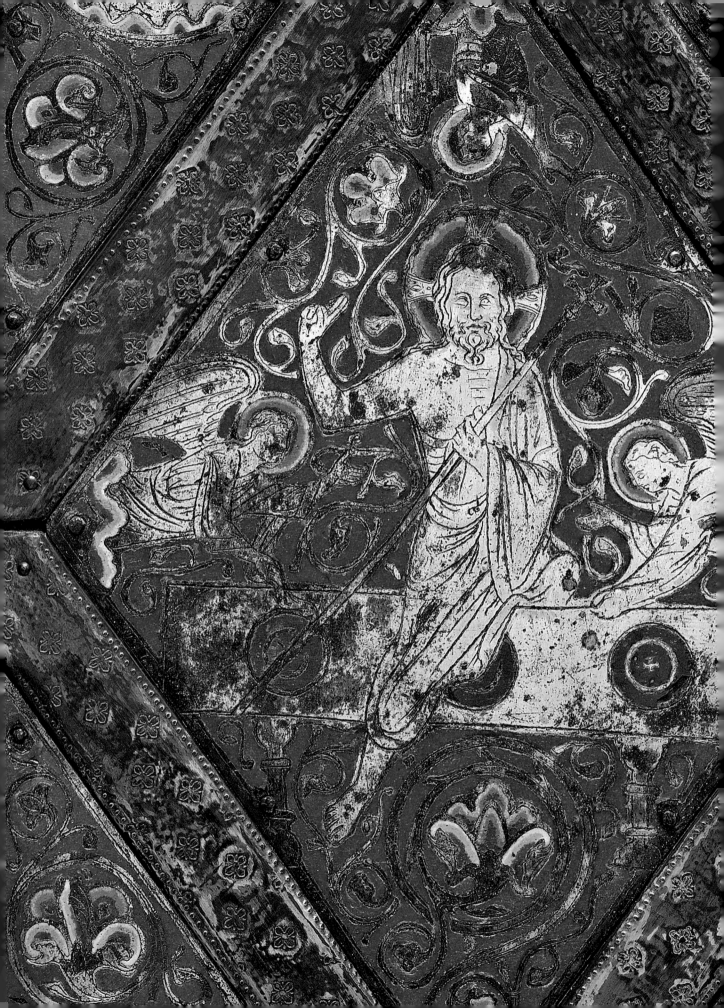

FOUNDATION STORIES OF CHRISTIAN ART

Attributed to Jean de Touyl (French, died 1349/50)

Reliquary Shrine

French, Paris, ca. 1325–50
Gilded silver, translucent enamel, and paint, 10 x 16 x 3⅝ in. (25.4 x 40.6 x 9.2 cm)
The Cloisters Collection, 1962 (62.96)

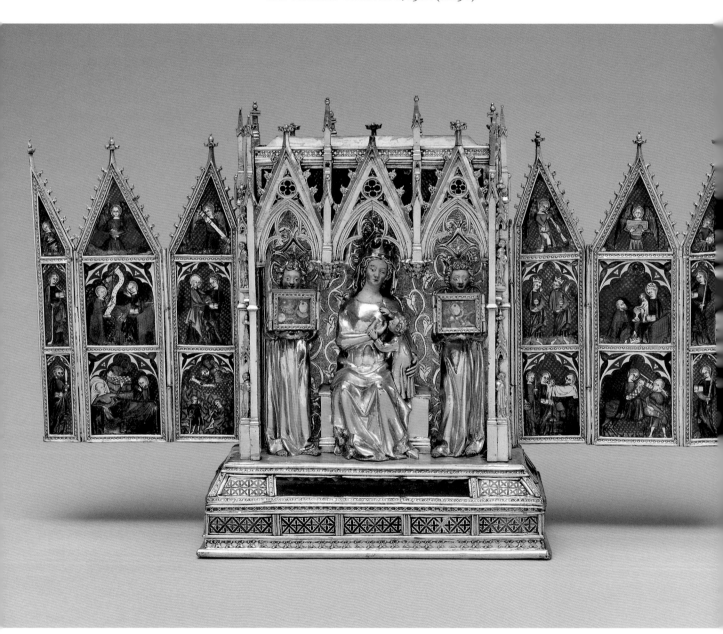

This sumptuous miniature shrine, meant to inspire private reflection and devotion, opens to reveal a golden Virgin nursing her child; on either side stands an angel holding a box of relics (see entry 16). The figures are set in an architectural fantasy that resembles a cathedral, including arches, tracery, and vaulting, soaring features of ecclesiastical Gothic architecture that evoke heaven. Colorful enamel as brilliant as stained-glass windows illuminates the wings of the shrine with scenes that relate the Nativity story. These episodes, based on Gospel accounts and also collectively called the Infancy cycle, represent key theological concepts and are among the most recognizable events depicted in medieval art. Here, each of the scenes is reduced to its essentials and contained within a space less than two inches across.

The story begins on the left wing of the shrine, in the upper central square panel. A winged angel points to an unfurled scroll, and a seated woman raises one hand in acknowledgment, their enlarged hands emphasizing the communication between them. This is the Annunciation, when the Archangel Gabriel, acting as God's messenger, tells Mary she will give birth to Jesus. Theologically, the Annunciation is regarded as the moment of the incarnation, the instant Jesus is believed to have taken on flesh within Mary's womb. That miracle is represented in many portrayals of the scene by the dove of the Holy Spirit.

Immediately to the right, the scene of two women tenderly embracing depicts the Visitation, when the pregnant Virgin Mary met with her cousin Elizabeth, who was also with child. That child was to become John the Baptist, Jesus's forerunner (see entry 14), who is said to have miraculously leapt within Elizabeth's womb in the first acknowledgment of Jesus's divinity.

The story continues in the square panel below the Annunciation with the Nativity, the birth of Jesus in a stable in the town of Bethlehem. Mary is reclining; Joseph, her husband, is nearby; and three farm animals look at the baby Jesus, who is tightly wrapped in crisscross swaddling clothes. The Gospel according to Luke specifies that the infant was placed in a manger, as seen here; most representations of the Nativity include

livestock to signify the setting's rusticity. The depiction of Jesus's human birth and modest origins is the prime scene of the Infancy cycle.

Immediately to the right of the Nativity, an angel holding a scroll approaches simply clad figures, one playing a horn, the other leaning on a staff, in a landscape with sheep. In this, the Annunciation to the Shepherds, the angel brings news of the birth of the Savior to humble people, instructing the surprised shepherds to seek a child in a manger. The narrative continues on the right wing's top register with the Adoration of the Magi, which encompasses two panels. On the left, two crowned men bear vessels; in the scene next to it, an elderly man kneels as he deferentially sets his crown on the ground and presents a similar vessel to a baby on a woman's lap. Like the shepherds, the Magi (kings or wise men) had heard about the miraculous birth and sought out the Child. They brought gifts of great value (gold, frankincense, and myrrh) and knelt in homage before the baby, signifying the Child's sovereignty over worldly wealth and rule. The message of the Nativity cycle is thus clearly directed to the meek and powerful alike.

In the left panel of the lower register is the Presentation in the Temple. In this Jewish ritual involving the first-born son, Mary presents her infant to a bearded man, who extends his covered hands to receive him. The elderly priest, Simeon, recognizes the Child's divinity—another revelation, this time to the authorities of the Hebrew temple, and thus another theologically important event.

In the final scene, the Flight into Egypt, Joseph leads a donkey as he looks back at his wife, Mary, who carries her swaddled son. Joseph had been warned in a dream that he should flee with Mary and Jesus, because the Roman governor Herod would seek to destroy the Child.

These vibrant and meticulously crafted scenes epitomize how efficiently medieval art recounted Christianity's complex foundation stories. Lending meaning as well as beauty, they adorn a shrine that is not merely an exquisite object but a functional reliquary with a moral purpose: to serve as an exemplar for the worshiper's behavior and as a focus for prayer enhanced by the relics' power.

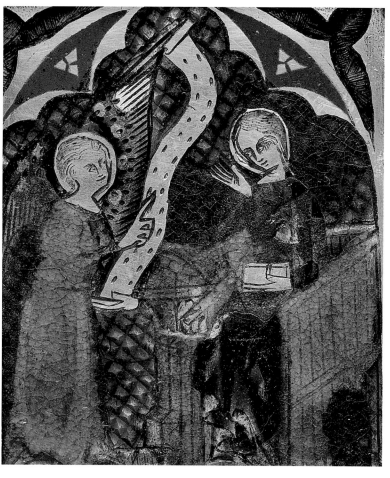

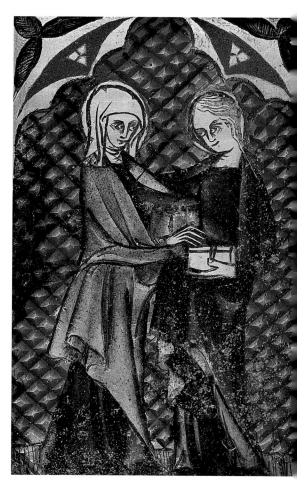

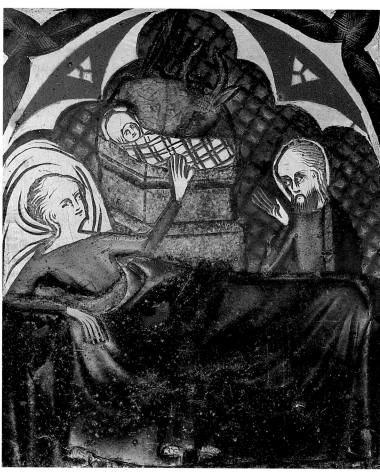

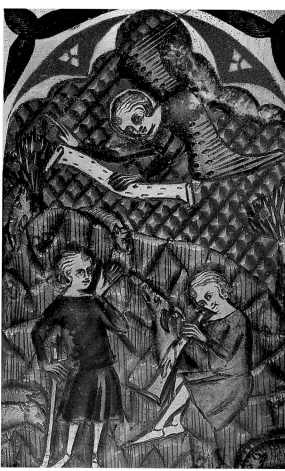

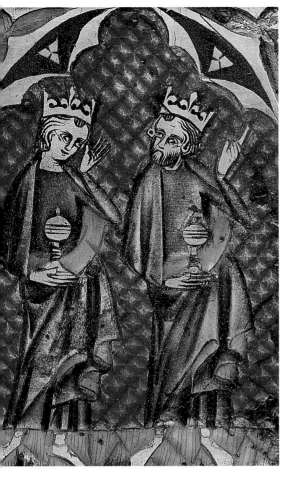
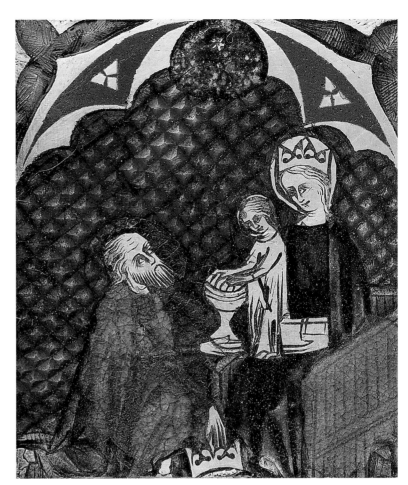
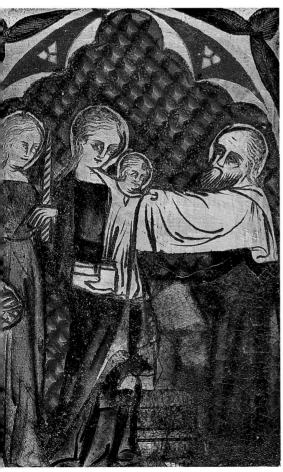
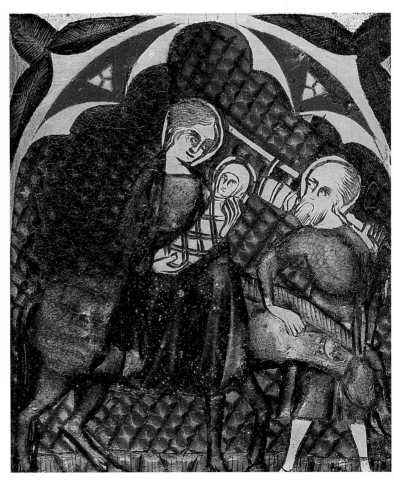

Triptych with the Passion of Christ

South German, ca. 1475–85
Mother-of-pearl, gilded wood frame, silk backing, and tooled leather covering,
8⅜ x 9½ x ⅞ in. (21.2 x 24 x 2.2 cm)
The Cloisters Collection, 2006 (2006.249)

The artist who made this triptych, or work in three panels, showed exceptional technical skill in a demanding medium, crisply rendering the facial features, the drapery, the anatomy of the crucified figures, and even the wood grain of the crosses in carved mother-of-pearl, a particularly brittle material. Equally remarkable is how deftly the artist conveyed the pathos of the Passion cycle, this triptych's subject, inspiring the viewer to empathize with Christ's suffering and sacrifice. This intricate piece is even smaller than the previous shrine and like it was used for private prayer and contemplation.

The Passion cycle is a series of events as important in Christian belief as the Nativity cycle (entry 1). As told in the Gospels, the drama begins with Jesus entering Jerusalem accompanied by his disciples, continues with his arrest and torture, and ends with his death on the cross. Here, eight key episodes are depicted in panels, each only about one inch square, on the two wings, with the large Crucifixion scene in the center.

The sequence begins with the second square from the top on the left-hand wing and proceeds clockwise. In the first scene, the Entry into Jerusalem, Jesus rides on a donkey toward a city gate, suggested here by a fortified arch with a raised portcullis. Two of his disciples follow him, with an extra halo behind them to indicate others. Jesus is distinguished by the cross in his halo (a cross nimbus) and the first two fingers of his right hand extended in a gesture of blessing.

The next image, at the top left, represents the Last Supper. Jesus sits behind a table surrounded by his apostles, with whom he shared a Passover seder, his last meal before his betrayal by his disciple Judas and his arrest. The minuscule size of the openwork panel prevented the carver from including all twelve apostles; six suffice to indicate the group. One of them, John, sleeps on Jesus's lap. The traitorous Judas, smaller than the other figures, sits isolated on the near side of the table; he is often singled out this way. The event is crucial in Christian theology, for it was at this meal that Jesus blessed bread and wine and said they were his body and blood, thereby instituting the Eucharist, the sacrament of the Mass in which consecrated bread and wine are ritually consumed in remembrance of his sacrifice.

Next, the top square of the right wing illustrates the Agony in the Garden of Gethsemane. Here, Jesus asks three of his apostles to stay awake while he prays to God the Father to take away the chalice (shown in the upper left corner), a metaphor for the ordeal he faces. The apostles sleep, demonstrating their weakness. The panel below, in which two men grasp Jesus by his arms, depicts the Arrest. The figure sheathing his sword is the apostle Peter (see entry 17), who has cut off the ear of Malchus, a servant of the Jewish high priest Caiaphas and a participant in the arrest; the two often appear in images of the incident.

The third scene on the right shows Jesus, who was judged by both religious and civil authorities, standing before a seated figure dressed in the manner of a high priest. (The high priest Caiaphas sentenced him to crucifixion; Pontius Pilate, a Roman official, is often shown symbolically washing his hands of the condemnation.) On the bottom of the right wing is the Flagellation, also known as the Scourging of Jesus. Jesus is tied to a column, stripped of his robes, and clad only in a loincloth. One figure raises a bundle of switches to whip him; another appears to cradle a club.

The Passion continues on the bottom of the left wing with the Crowning with Thorns. Jesus, attired in a long robe, sits holding a reed as if a scepter, and two

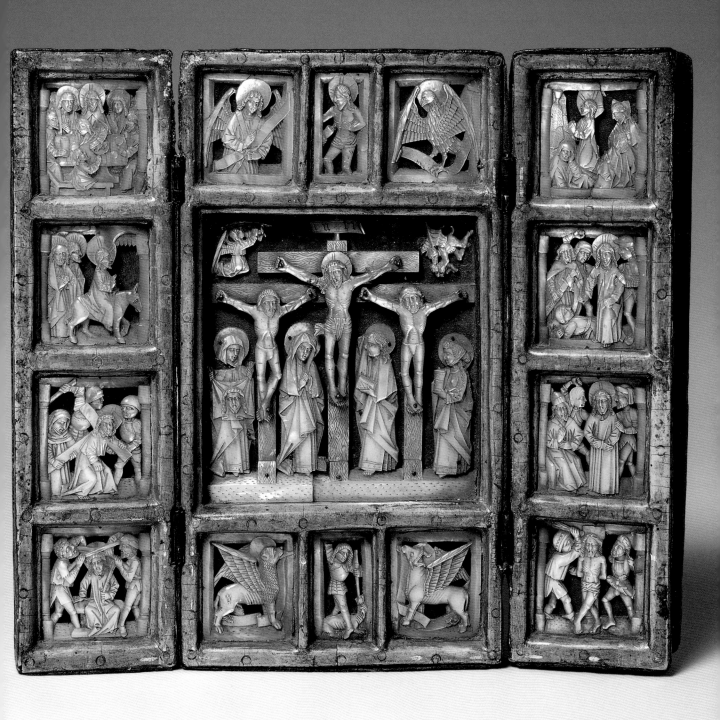

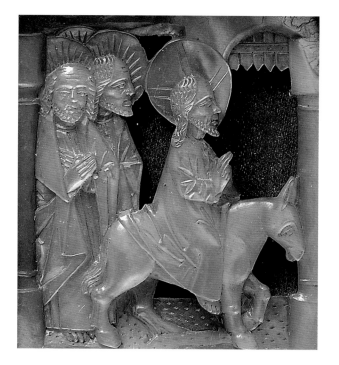

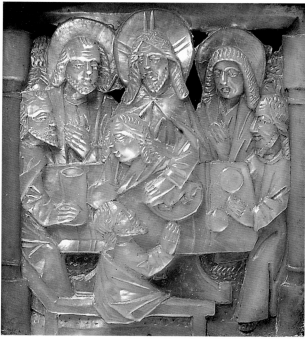

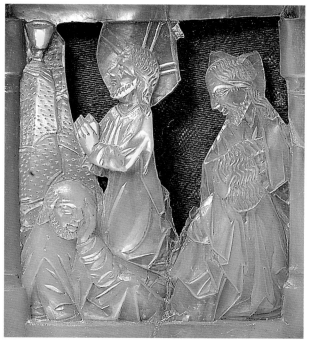

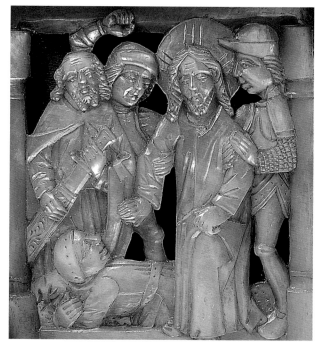

bearded men use long crossed poles to tighten a thorny wreath on his head; the reed and crown of thorns are mocking references to the so-called king of the Jews. Like the previous scene, this one gives vivid expression to the agonizing torture and ridicule Jesus suffered. The next episode, in the panel above, is Carrying the Cross. Two armored soldiers pull and push Jesus forward mercilessly as he struggles to bear the heavy instrument of his death.

Their cruelty is offset by the compassion exemplified by a hooded man, Simon of Cyrene, who steps forward to help him.

Befitting its importance, the Crucifixion, the culminating event in the Passion cycle, occupies the central and largest panel; the Evangelist symbols (see entry 16) appear at its four corners. The scene is portrayed in art of the Middle Ages with varying levels of detail (see entries

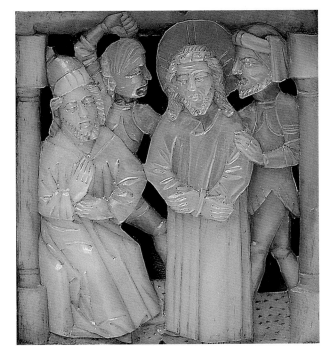

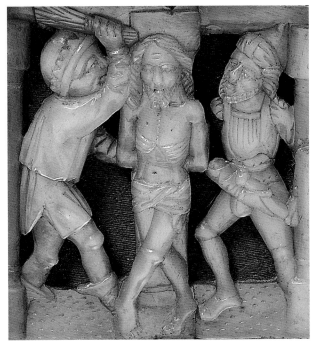

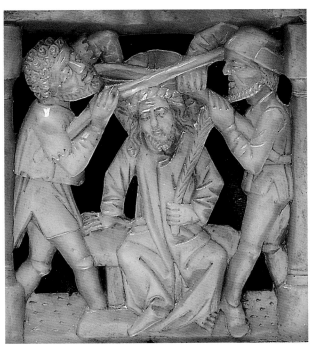

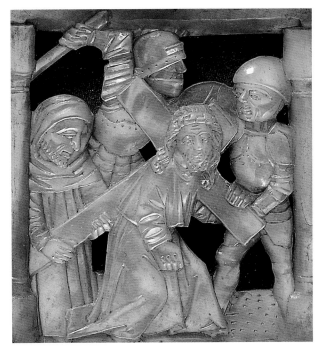

30–33). Typically, the base of the cross is flanked by Mary, Jesus's mother, and John, the beloved youngest apostle. Here, the two thieves said to have been crucified beside Jesus are also shown, with an angel above the so-called good thief and a devil over the bad thief, each holding a tiny figure signifying the respective thief's soul. The representation also includes two female saints: Veronica, holding her veil with its image of Christ, believed to be the miraculous result of her wiping his face on the way to the cross, and Mary Magdalen with a jar, her attribute, which refers to her carrying spices to anoint Jesus at the tomb.

The wings of this diminutive triptych can be folded to enclose the central scene and protect the delicate carving, making this rendition of the tragic story as portable as a small paperback book, readily available for the owner's private devotion.

Tabernacle of Cherves

French, Limoges, ca. 1220–30
Champlevé enamel on gilded copper, 30¾ x 35⅞ x 9⅞ in. (78 x 91 x 25 cm)
Gift of J. Pierpont Morgan, 1917 (17.190.735)

This large tabernacle, or ornamental religious cupboard, is decorated with reliefs and engravings of the events of the Post-Crucifixion cycle, the third cycle in the life of Jesus, a theologically significant period between his crucifixion and his ascension to heaven. Many of the scenes concern Jesus's physical presence on earth after his death. The subject suits the object's original function as a container for the host, the Eucharist wafer that is consecrated in the sacrament of the Mass and represents the body of Christ.

The tabernacle's doors open to reveal seven vignettes, three in medallions on each wing and, in the center, a large tableau of applied gilded figures showing the main subject, the Deposition, or the Descent from the Cross. Jesus's lifeless form is gently removed from the cross by Joseph of Arimathea, who donated his own tomb for Jesus's burial. At the left, Mary tenderly holds her dead son's hands. At the right (not visible here), the young apostle John stands grieving. The kneeling figure is Nicodemus, who also assisted with the deposition and here removes a nail from Jesus's foot with a hammer and pliers. Two angels attend, holding the sun and moon, symbolizing all of creation's grief over his death.

The story continues on the open doors in gilded openwork roundels attached to the enameled copper ground. In the first scene, at lower left, a crowned Christ grasps the hand of one of several figures who are climbing out of the mouth of a dragon, representing hell. He has gone to the underworld to rescue the righteous, an extrabiblical episode known as the Descent into Limbo or the Harrowing of Hell. This event, said to have taken place after Jesus's burial, is especially important in Byzantine art, in which it is called the Anastasis (see entry 6). In the second scene, in the central medallion on the left, three

women approach a winged figure at a large tablelike structure representing the tomb where Jesus had been buried. This portrays the gathering at his tomb of the Three Holy Women, commonly called the Three Marys (Mary Magdalen and others variously identified in the Gospels). They brought jars of spices to anoint Jesus's body, only to be told by an angel that he was not there.

In the top medallion on the left, a kneeling woman reaches out to the standing figure of the crowned Christ, who deflects her hand. The event is the Noli Me Tangere, Latin for "touch me not," Christ's instruction to Mary Magdalen when he first appeared after his resurrection. The medallion on the top of the right door, showing Christ exposing his wound to the doubting apostle Thomas, conveys an opposite message. Whereas Christ told Mary Magdalen not to touch him, he invites Thomas to verify that he is indeed Jesus, now the risen Christ, by touching his wounds.

The two remaining medallions on the right wing recount additional appearances of Christ to his followers. The lower one presents the Road to Emmaus: two figures, apostles of Jesus, stand outside city walls speaking with the risen Christ without recognizing him. In the Supper at Emmaus, depicted in the medallion above, they realize who he is when Christ holds up a loaf of bread and a chalice, alluding to the Last Supper, when Jesus told the apostles that the bread and wine were his body and blood.

The artist deliberately established compositional and theological parallels across the object, using visual echoes to draw attention to the linked content of the medallions paired on left and right. As discussed, both scenes in the top medallions involve touching Christ; in both, a botanical form on a long stalk suggests a garden setting. The

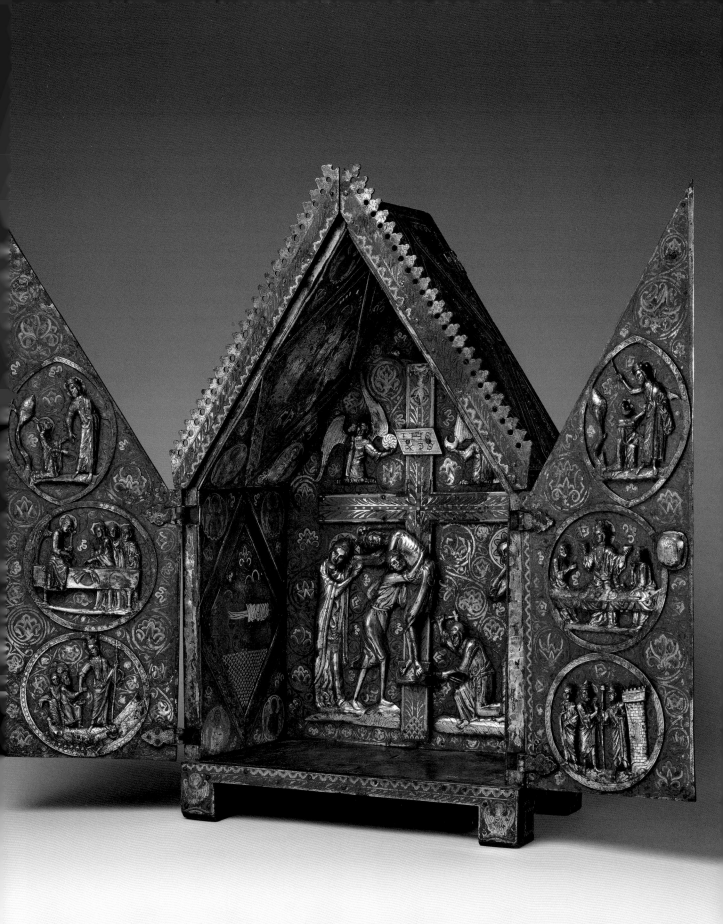

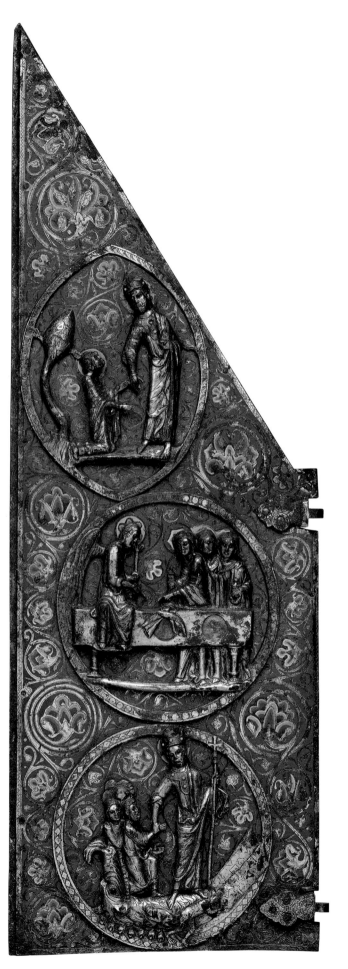
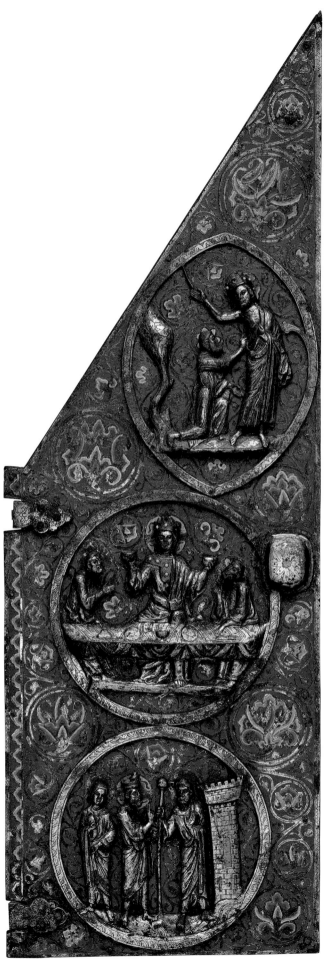

center left scene concerns the absence of Jesus's body; in its opposite, Christ presents the bread as his body. In both of the lower roundels Christ carries a large staff and assists two other figures on a journey.

Additional scenes, engraved and enameled in diamond-shaped panels on the inside walls and ceiling of the cupboard, extend the chronology and repertoire of Post-Crucifixion events. A panel on the left wall of the interior shows the Entombment of Christ, chronologically the first event after the Deposition. A bearded male figure, with others behind him, anoints the body of Jesus with oil. At the left, the grieving Virgin looks down at her son, her cheek nearly touching his, in another recurring scene called the Lamentation (see entry 5). On the right wall of the interior is the Resurrection, Christ rising from his grave on the third day after his crucifixion. Christ steps boldly out of the tomb, accompanied by two angels, a

dynamic, triumphant scene that contrasts with the quiet pathos of the Entombment opposite. On the interior's ceiling are two more engraved lozenges; the one on the right is a replacement for a lost original. The one on the left presents the Ascension of Christ into heaven, said to have occurred forty days after his resurrection. The tall figure of Christ stands in the center, hands raised in blessing, flanked by two groups of disciples. The symmetrical and static composition emphasizes Christ's importance while barely suggesting his ascent.

Both the sculptural scenes on the doors and central panel and the delicate engravings on the tabernacle's inside walls are set against an enameled blue ground embellished with scrolling floral motifs highlighted in turquoise and white. Altogether, the object is a masterpiece of varied metalwork techniques that amplify the significance of a functional liturgical cabinet.

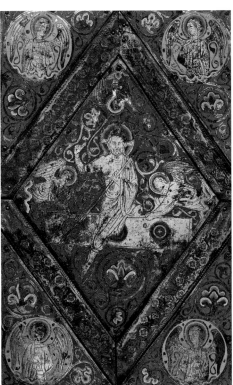
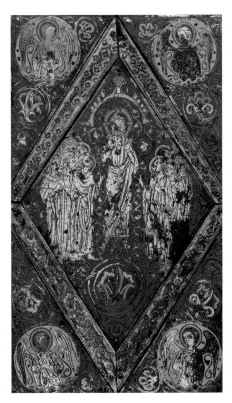

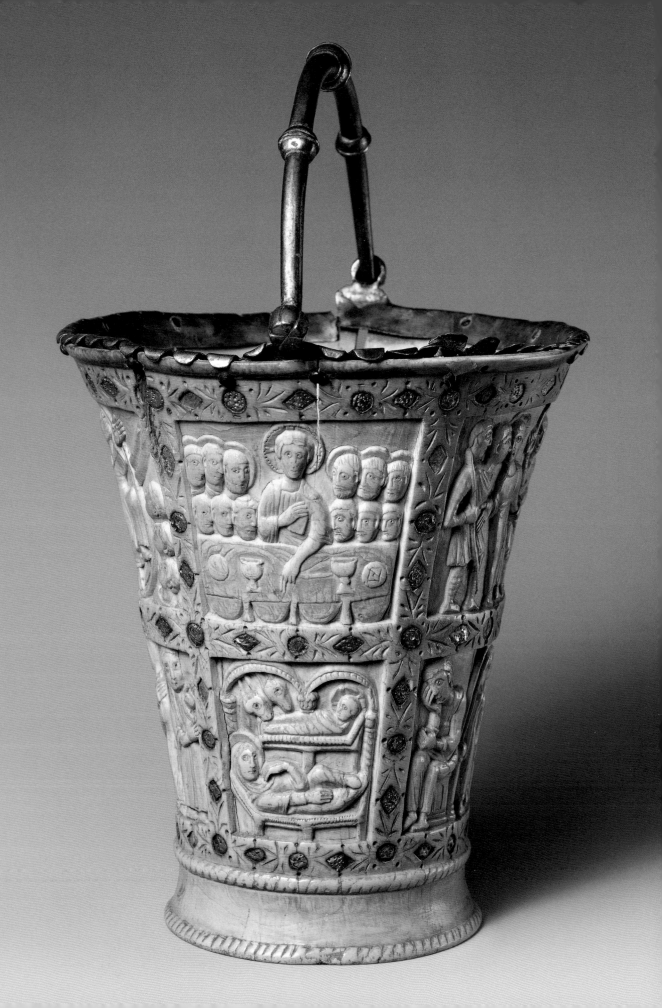

4

Situla

Carolingian, northern France, 860–80
Ivory with gilded copper-alloy mounts and foil inlays,
H. (vessel only) 5¾ in. (14.6 cm), Diam. at top 5⅛ in. (12.8 cm)
Gift of J. Pierpont Morgan, 1917 (17.190.45)

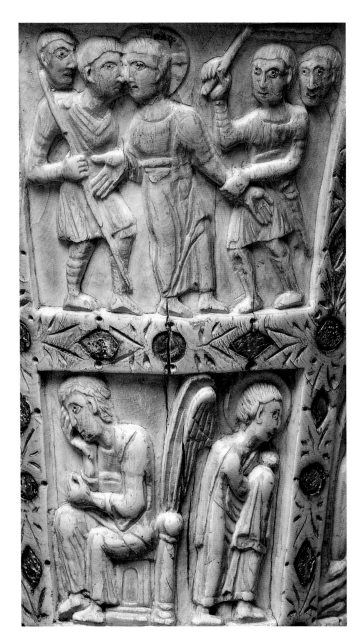

Representations of the Infancy, Passion, and Post-Crucifixion narratives (entries 1, 2, 3) were extremely familiar to the medieval viewer, and were intended not merely to illustrate a story but also to inspire reflection. The scenes could be juxtaposed in many permutations to invite further contemplation. The way nine episodes of the three cycles are combined and aligned on this vessel, a situla, highlights subtleties of meaning and interpretation.

Situlas are ritual buckets used to carry holy water, which was sprinkled on the altar and the faithful during church ceremonies. This example is made of ivory, a precious and expensive commodity, to honor its important liturgical function. Two registers of scenes with borders embellished with golden foil wrap around the vessel. Views from the Infancy cycle appear on the lower level. On the upper register, the scenes derive from both the Passion and Post-Crucifixion cycles. Each row reads in chronological order counterclockwise around the work.

The upper register begins with the Last Supper, followed by the Arrest, the Crucifixion, the Three Holy Women at the Tomb, and the Ascension, here portraying Christ striding upward, as if on a stairway. The Last Supper includes all twelve apostles, their heads neatly stacked on either side of Jesus. The Arrest hints at the Betrayal of Jesus; the figure to his left seems close enough to kiss him, as Judas is believed to have done to identify Jesus to his captors. It is not uncommon for works to combine imagery representing the Betrayal and the Arrest.

Scenes in the lower register include the Annunciation, the Visitation, the Nativity, and the Baptism of Jesus by John the Baptist (see entry 14). Although the latter event is not part of the Infancy cycle, its inclusion on an object used to carry water is fitting. Reading the scenes in

this row can be challenging, because some of them extend beyond the ornamental borders. For example, the Nativity is given the most expansive treatment in the lower register; it continues beyond the frame on both sides, to the left with a veiled woman representing a midwife, and to the right with Joseph sitting, head in hand. Joseph is back to back with a standing angel. That angel participates in the Baptism scene to the right; the fabric in its hands is the garment that is to clothe the baptized Jesus.

The chronological arrangement of scenes around the situla invites the viewer to read them horizontally, but the scenes' vertical relationships reveal further doctrinal insights. The placement of the Infancy cycle below the Passion and Post-Crucifixion scenes conveys the spiritual progression from earthly to heavenly. Above the Nativity is the Last Supper, linking the first event in the life of Jesus with the first in his Passion. The pairing of the Annunciation with the Three Holy Women at the Tomb, two episodes centered on angels communicating divine information to those on earth, is underscored by the similar gestures of the angels and the direct exchange of gazes in each scene.

The carvings on this luxurious situla engage the viewer with endearing, humanizing details, such as the alert beasts hovering protectively over the swaddled baby Jesus in the Nativity panel. In the Ascension, Christ's muscular stride conveys his triumph, as do his upturned head and outstretched arms, which seem to embrace his heavenly destination joyfully. The figures in all the scenes, while small, have enlarged hands, the more clearly to communicate their gestures and their messages. These doll-like actors play out key moments of the Christian story with expressive charm.

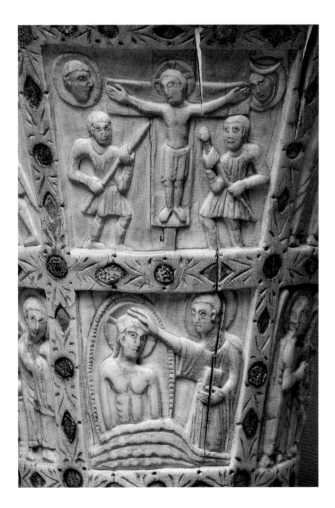

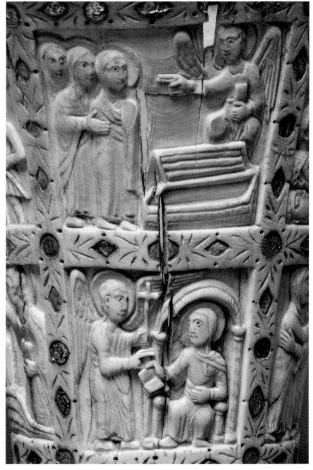

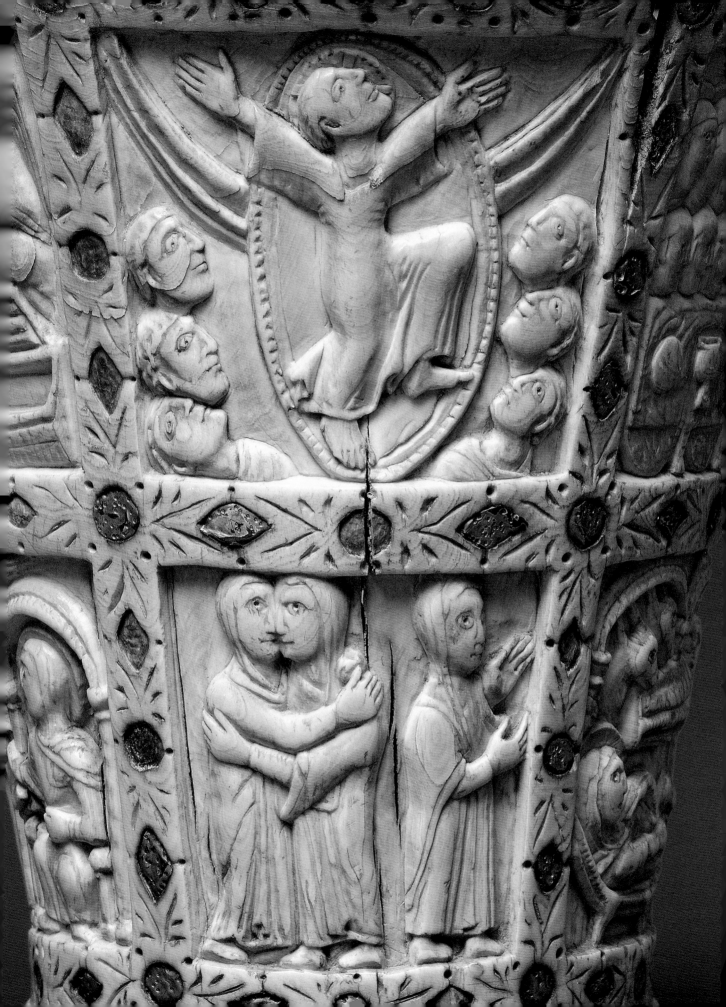

Jean Pucelle (French, active Paris 1319–34)

The Hours of Jeanne d'Evreux, Queen of France

French, Paris, ca. 1324–28
Grisaille, tempera, and ink on vellum, each folio 3⅝ x 2½ in. (9.2 x 6.2 cm); 209 leaves
The Cloisters Collection, 1954 (54.1.2)

The Hours of Jeanne d'Evreux, a tiny Book of Hours made for a queen of France, is one of the great treasures of The Cloisters collection. The pages are smaller than playing cards, yet they are filled with lively action and delicate, intricate detail. (Shown below at actual size are the Arrest and the Annunciation, fols. 15r, 16v.) The figures are skillfully modeled in grisaille (shades of gray), which endows them with a sculptural presence that enhances their emotional resonance. The book contains twenty-five full-page paintings, including illuminations of a complete Infancy cycle, each scene paired with one from the Passion. The eight pairings (two of which are discussed

here) both encourage theological reflection and suggest that Jesus's tragic destiny was implicit from conception. These scenes amplify the story with anecdote and drama, typical of the tendency in later medieval art to encourage empathetic reading of sacred narratives.

The Crucifixion (fol. 68v, at left opposite) is the only illumination in the manuscript that fills an entire page, with neither framing architecture nor text below. It is as though the scene were too large and momentous to be confined by a restricting border. At the top of the page, two angels hold the sun and the moon, here referring to the darkness that overcame the sun that day. Two grieving

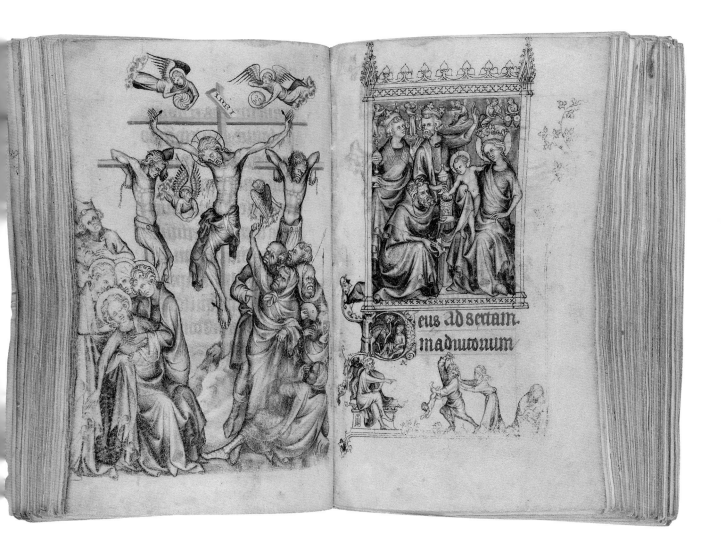

eus ad sextam.
madiutonum

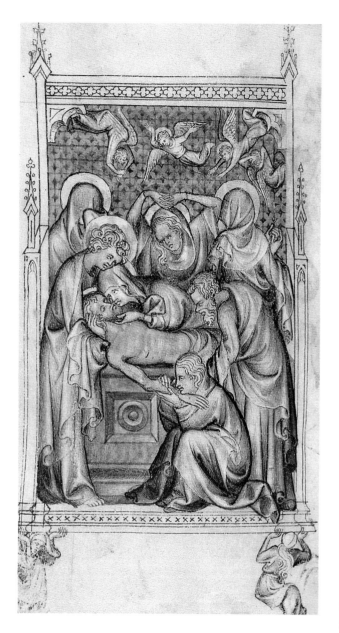

On the facing page (fol. 69r), the three Magi approach the crowned Virgin and Child. Above their heads, tiny joyful angels play music. The kings offer gifts in precious vessels, which are similar to those used in late Gothic princely households and in churches. The king who kneels before Jesus has removed his crown in a sign of respect. The nobility of the kings in the Adoration contrasts with the low savagery of the taunting figures in the Crucifixion.

In the next pair of images shown here, John the Evangelist and Joseph of Arimathea, the Samaritan who offered his tomb for the burial of Jesus, gently lower his body onto a blue coffin, surrounded by five expressively mourning figures (fol. 82v, at left). Mary places her cheek next to that of her son as she cradles his head, a Lamentation scene that is a forerunner of the Pietà (see entry 25). A woman standing behind her raises both arms in agony. The mourners' distress is shared by the four angels at the top of the scene, who seem to spin and gyrate in grief.

On the right-hand page (fol. 83r, opposite), Mary embraces her swaddled newborn son as she rides a donkey led by Joseph, who glances back toward his family with a worried expression. Even the donkey seems to look up to the Holy Family with concern. The decorative background includes lilac-blue scrolling vines enclosing tiny threatening faces. The Gospel account of the Flight into Egypt specifies that it took place at night, and both the dark background and the ghoulish figures suggest the special dangers of travel after nightfall. As in the opposite scene, Mary is shown cheek to cheek with her son, her embrace adding poignancy to the juxtaposition of images of Jesus's death averted and consummated. Among the marginal figures below the scene are two naked figures tumbling from pastel-colored pedestals. They illustrate a story in the Apocryphal Gospels that recounts how statues of pagan gods spontaneously fell when the Holy Family passed by en route to Egypt.

This appealing little book narrates these episodes with elegance and spiritual force yet also includes engaging and purely entertaining elements. While the illuminations convey the gravity of the Gospel narratives, they are surrounded by nondoctrinal supporting creatures that gambol in the margins (see entry 37).

angels fly just beneath the arms of the cross. Jesus is shown between the two thieves who were crucified with him. At the foot of the cross, Mary swoons in anguish; she is supported by John the Evangelist, the beloved youngest apostle. Contrasting with these holy figures, a taunting mob stands on the other side of the cross. The placement of bad characters on Jesus's sinister (Latin for "left") side is an often-used visual convention.

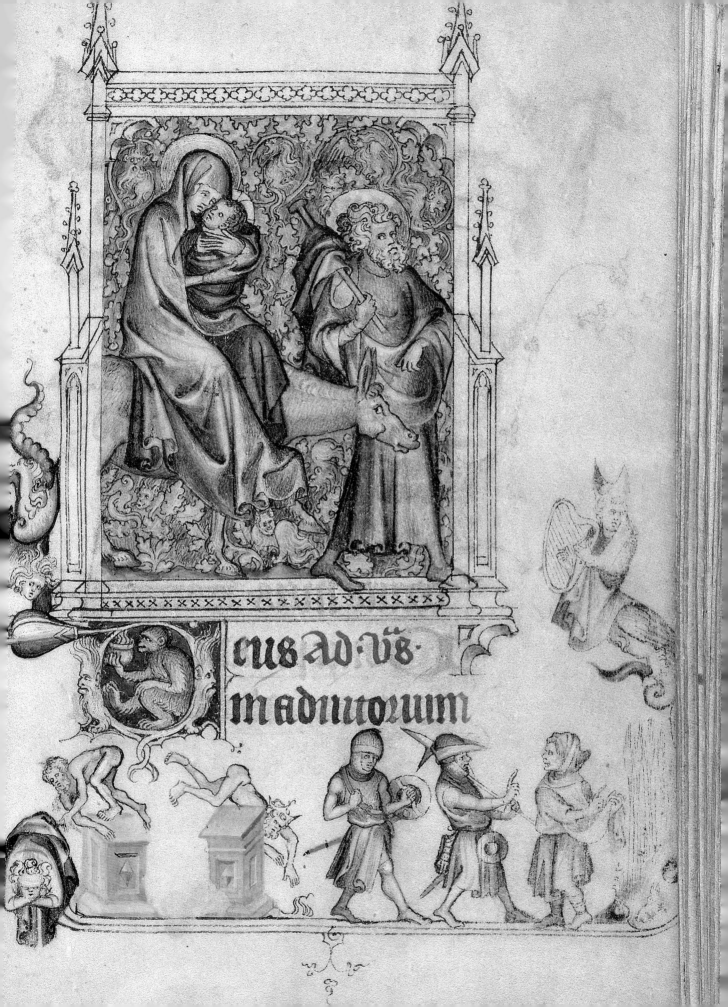

eus ad ꝰs
madintoꝛium

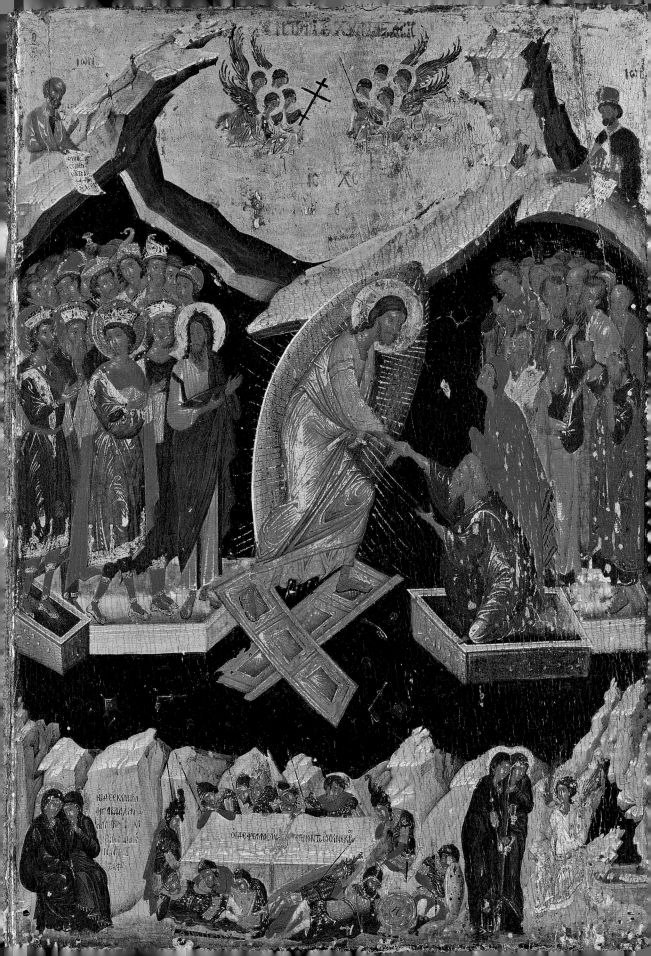

Icon of the Harrowing of Hell (Anastasis)

Byzantine, early 15th century
Tempera and gold on wood, 10⅜ x 7¼ in. (26.2 x 18.4 cm)
Purchase, Mary and Michael Jaharis Gift, 2013 (2013.980c)

In this dynamic image, Christ appears with a golden halo and robe, surrounded by radiating gold lines. Having broken the gates of the underworld, he strides across the shattered pieces and energetically extends his hand across the black chasm to lift good souls from their graves. Adam is the first to be redeemed; Eve is next in line, followed by a procession of others. On the left, gesturing toward Christ, stands John the Baptist (see entry 14), identifiable here by his unruly hair; other righteous figures, kings and warriors, group behind him. Below the main scene, smaller-scale images show other events from the Post-Crucifixion cycle (entry 3), identified with Greek inscriptions quoting Gospel passages: At left, two holy women sit at the tomb; in the center, soldiers sleep around the sealed tomb; and at right, the two holy women approach an angel, who points to an empty shroud, indicating that Christ has risen. At the top of the panel, angels hold the cross and other instruments of Christ's Passion, such as the lance that pierced his side. In each of the upper corners, a prophet holding a scroll perches on the mountains that rise above the underworld's abyss.

The central scene of the risen Christ redeeming souls is known as the Harrowing of Hell or the Descent into Limbo in the Latin Church and as the Anastasis (meaning "stand up") in the Greek Church. Orthodox depictions of the Resurrection show this scene rather than Christ rising from the tomb, which is typical in the West.

In Byzantine art, representations of sacred persons or events such as this are known as icons (from *eikon*, Greek for "image"). In Orthodox theology, icons are themselves venerated and, by connecting the worshiper to the individuals or story depicted, are thought to direct prayer to heaven: "For the honor which is paid to the image passes on to that which the image represents, and he who reveres the image reveres in it the subject represented" (resolution of the Second Council of Nicaea, 787).

Icons often are painted on portable wooden panels like this one, but they can be of any size, tiny or monumental, and in any medium, including ivory, metal, mosaic, and fresco (see entry 27 and fig. 22). Individual freestanding icons were sometimes grouped into narrative cycles recounting Jesus's life and death. The present panel is from such a cycle, a set of at least eight icons that originally were mounted together, perhaps as a polyptych or as doors to a larger icon.

Key episodes from the Nativity, Passion, and Post-Crucifixion cycles are generally linked in Byzantine art to the calendar of great feasts celebrated annually in the Orthodox Church. Each of the feasts has a corresponding iconic image; for example, the Nativity illustrates Christmas; the Anastasis is associated with Easter, the celebration of the Resurrection. For each image associated with the cycle of feasts, certain aspects of the story are standardized and nearly always included—for example, Christ breaking the gates and reaching to Adam and Eve in the Anastasis. The consistency and familiarity of the iconography guaranteed the power and clarity of its message and thus the icon's value as a vehicle for prayer.

This work displays the elegant elongated figures typical of much late Byzantine painting. The gold background and gold highlights on Christ's robes would have glittered in a candlelit church and elevated the scene to a heavenly realm.

Diptych with the Coronation of the Virgin and the Last Judgment

French, probably Paris, ca. 1260–70
Elephant ivory, 5 x 5⅛ x ¾ in. (12.7 x 13 x 1.9 cm)
The Cloisters Collection, 1970 (1970.324.7a, b)

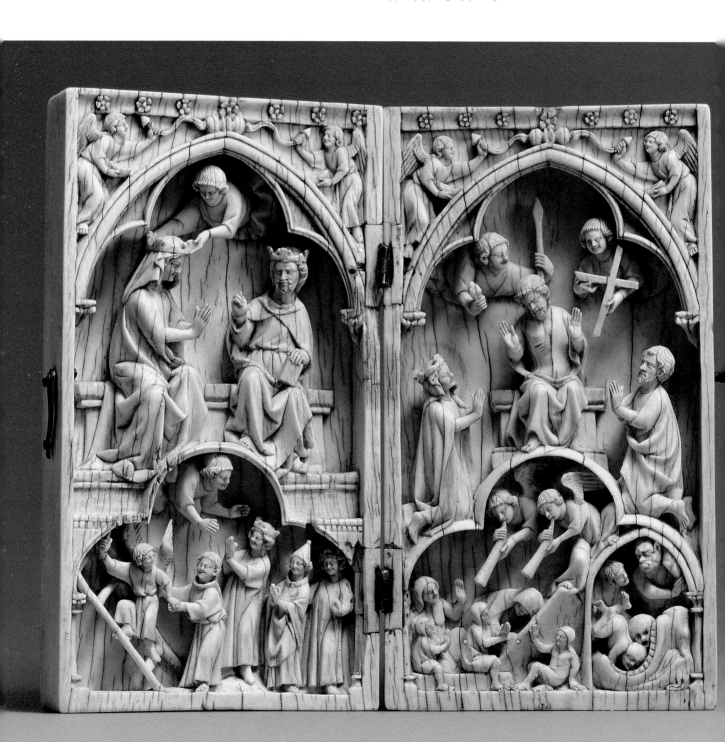

This ivory diptych, or work in two parts, is carved with such extraordinary skill that the figures advance three-dimensionally from the background. The tiny ladder at lower left and the extended, gesturing hands of many figures display the artist's daring prowess in carving and undercutting a precious and fragile material. Like the six previous pieces, it portrays important scenes widely encountered in medieval art. But, unlike the others, the events shown here were not drawn from the three principal narrative cycles of Christian art, and they take place outside of earthly time.

Each side of this diptych situates its main subject under a Gothic arch, with a lower zone under round trefoil arches that extends across both panels. On the left wing is the Coronation of the Virgin, a ceremony set in heaven following Mary's death. An angel crowns the Virgin, who extends her hands in prayer toward the crowned, seated figure of Christ. In many other depictions of this occasion, it is Christ who places the crown on her head. The Bible does not mention the event, but it became a popular scene from the end of the twelfth century on, as devotion to Mary increased (see entries 22–29). The Coronation of the Virgin is featured on the facades of many important thirteenth-century Gothic cathedrals, including the Notre-Dame cathedrals in Paris, Amiens, and Reims, France. Like Jesus and his followers, Mary lived and died in the past, in the time of the Roman Empire; in a narrative sense, her coronation took place in the past as well. But her coronation also exists in a more ambiguous time—past yet eternally present in a timeless heaven.

On the right panel, Christ appears seated in heaven, displaying his wounds as angels above hold instruments of the Passion. Christ is flanked by the Virgin and John the Baptist (entry 14), kneeling in prayer as they intercede on behalf of the souls below. (For more on intercession, see entry 28.) These three are the key figures in the Last Judgment; those being judged occupy the lower zone of the diptych.

On the lower right panel are angels, one ingeniously perched on the architecture, blowing trumpets to wake the dead. The trumpets are so large we can almost hear their call. To the right (but below the left, or sinister, hand

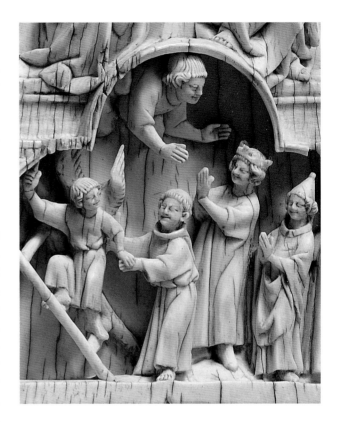

of Christ), those who are damned tumble headfirst into a toothy mouth of hell overseen by a monster. At the lower left are the elect, or saved, among them a monk, a king, and a bishop or pope. Beaming, they are led by an angel up a ladder to the heavenly zone. Their infectious smiles engage the viewer and suggest the reward awaiting the faithful. The Last Judgment is understood to be taking place in the future, at the end of time, yet the elect are depicted as people of the period when the ivory was made, and they are climbing toward a zone depicting an event in the past. The juxtaposition of this scene with Mary's coronation above wonderfully illustrates the medieval conception of time, an eschatological view that fuses past, present, and future.

This object would have served as the focus of the owner's private devotion. It could be set up on a stand or stood up like an open book. However, its small size also permitted the worshiper to hold this precious object in cupped hands, to delight in its beauty and to be inspired to choose the path of the happy figures here, the elect.

THE HEBREW BIBLE
AND JEWISH ART

Plate with the Battle of David and Goliath

Byzantine, Constantinople, 629–30
Silver, Diam. 19½ in. (49.4 cm), 12 lb. 12 oz. (5.78 kg)
Gift of J. Pierpont Morgan, 1917 (17.190.396)

This heavy, solid silver plate celebrates David, a hero of the Hebrew Bible. It is the largest and central piece of an elaborate set of nine, among the chief treasures of the Metropolitan Museum's medieval collection. The plates, intended for display, dramatize David's early years, highlighting his victory in battle over the Philistine giant Goliath, enemy of the kingdom of Israel.

Three moments in the battle are depicted in three registers, meant to be read from top to bottom. At top, the haloed David and the helmeted giant, Goliath, each raise a hand, gesturing their challenge to one another. Each emerges from a city rendered in miniature, signifying their warring kingdoms. The hand of God, pointing toward David to indicate that he is favored, emerges from a semicircle decorated with the sun, moon, and stars, representing the firmament. Between the two combatants is a seated seminude figure, a classical personification, like the representations of river gods familiar in ancient Roman art; here it refers to the brook where David picked up

the stones to arm his sling. In the central register, the protagonists battle, Goliath with spear, shield, and helmet, and David with only his fluttering cloak and slingshot. While Goliath lunges forward and David leans back, the alarm registered by Goliath's soldiers, who shrink away in fear, signals the battle's outcome. A wealth of detail enlivens the representation: the modeled muscles of the combatants' forearms and legs, the fine punchwork on the shields, the soldiers' elaborate armor, the fancy footwear and articulated toenails, and the embroidered edging on David's drapery. In the bottom register, the only one showing David notably smaller than Goliath, David cuts off the head of the giant, whose armor lies on the ground to the right. The three round objects at the left and the snakelike one above them represent David's three rocks and sling in a kind of narrative shorthand that is out of scale with the figures, emphasizing their importance.

This spatial representation is one of several conventions used here that sacrifice illusionism to convey the

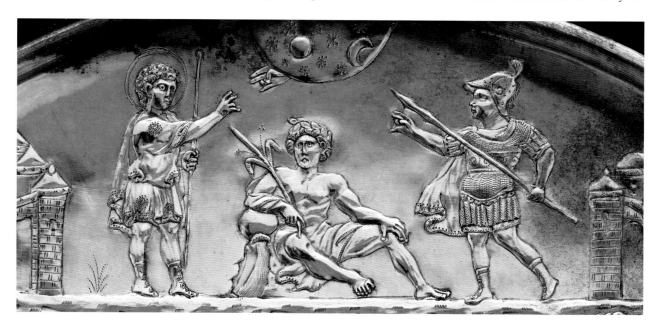

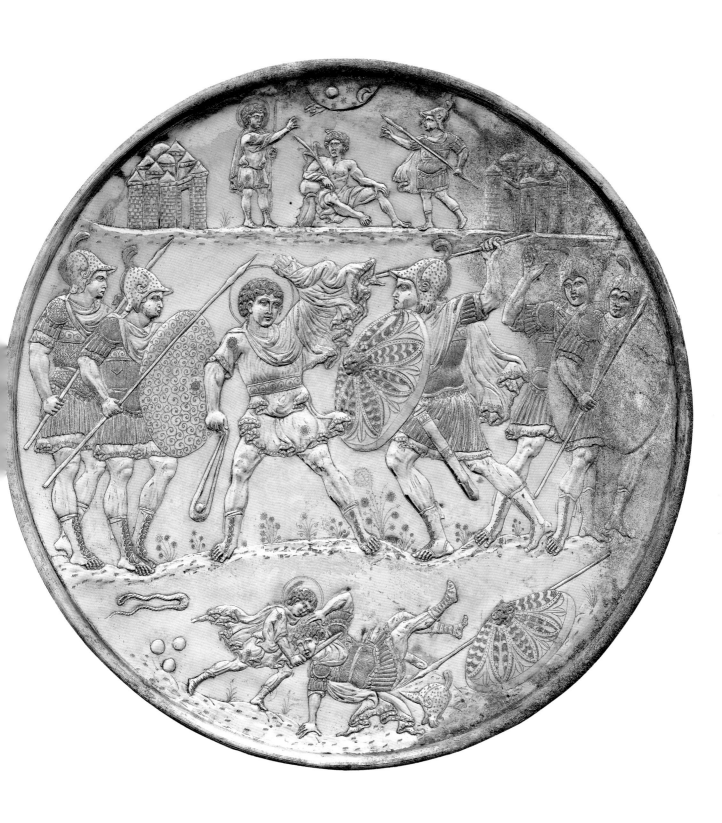

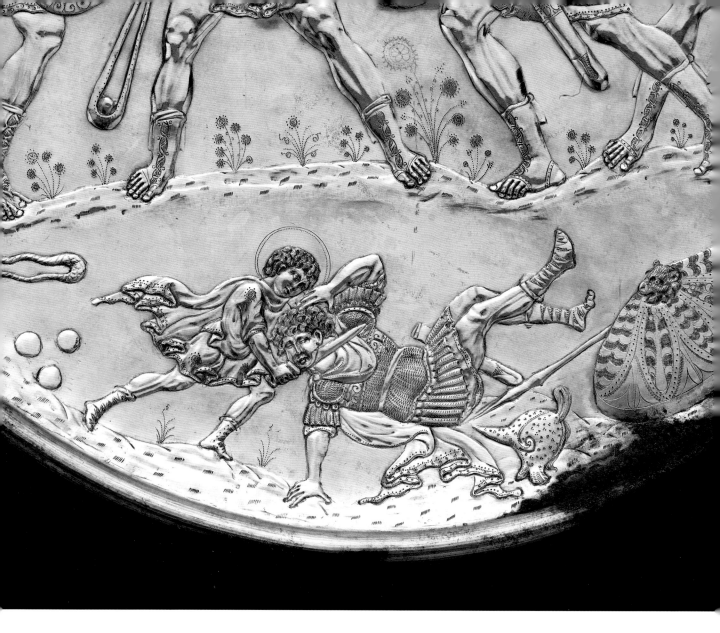

story succinctly. Similarly, the full-scale figures at the top are juxtaposed with diminutive cities. In this same upper register, symbolic representations of differing religions (the hand of the biblical God and a pagan river god) coexist. At the bottom, weapons float above the ground, apparently in the absence of gravity. Finally, the plate as a whole represents three moments of a story at once, like a cartoon with three panels.

These spatial and narrative conventions, typical of much medieval art, combine with elements of classical style that are employed with extraordinary skill. The quality of the modeling in relief, the indication of movement in the drapery, and the articulation of the musculature all speak to the classicism popular under the Byzantine emperor Heraclius (ruled 610–41).

We know this silver plate was made during Heraclius's reign because the reverse bears his control stamps; silver in the Byzantine Empire was often marked with the emperor's control stamps to assure the metal's purity. Moreover, Heraclius, one of the greatest, most educated,

Figure 12. Plate with the Presentation of David to Saul. Byzantine, Constantinople, 629–30. Silver, Diam. 10¾ in. (27.2 cm), 3 lb. 1 oz. (1.4 kg). Gift of J. Pierpont Morgan, 1917 (17.190.397)

and strongest of the Byzantine emperors, is subtly referenced in the imagery on the set of plates. Scenes on some of the smaller plates recall the Heraclian imperial court, its architecture, hierarchical formality, and dress (fig. 12). Heraclius himself was called a new David by contemporary and later authors, who praised him for the reconquest of parts of the empire that had been lost to the Persians. Further, Heraclius was legendarily reputed to have engaged in one-to-one combat with the Persian general Razatis in 627, during the recapture of Jerusalem, much as David defeated Goliath to save Israel from the Philistines. Whether or not Heraclius himself commissioned the plates to commemorate his victories of 627–29, they constitute a landmark in the history of art, as they are extraordinary in quality, reflect a critical moment in history, and may employ a biblical story to celebrate a contemporary event. They skillfully adopt the visual language of the Roman Empire to emphasize its continuity with a Christian one.

Abiud

French, from the Abbey Church of Saint-Yved, Braine, 1195–1205
Pot-metal glass, vitreous paint, and lead, 76⅜ x 34⅞ x 1½ in. (194 x 88.6 x 3.8 cm)
Rogers Fund, 1914 (14.47a–c)

This arched panel is an example of stained glass, an artistic medium closely associated with Gothic architecture. The Gothic cathedral was viewed as an earthly embodiment of the Heavenly Jerusalem, the city of God, and the sun shining through stained glass dissolved its stone walls into colored light, spurring contemplation of divine light. This panel's saturated colors, especially the blue and red, are jewel-like in intensity; late medieval glass is often less deeply hued than this, permitting the transmission of more light.

A bearded, enthroned man in layered drapery points with one hand and grasps the folds of his garment with the other. His name, Abiud, is inscribed in formal capital letters on either side of his halo. The panel is most likely from the clerestory, or upper level, of a monastic church in Braine, France, much of which was destroyed in the eighteenth and nineteenth centuries. The figure's large size, more than six feet tall if it were standing, would have helped it to be seen clearly in its original location, high up near the church ceiling.

Although neither the Hebrew Bible nor the New Testament provides narrative information about Abiud, a variant of his name appears in the genealogy in 1 Chronicles, and he is among the ancestors of Jesus listed in the first chapter of the Book of Matthew. Many cultures use genealogies to authenticate individuals' legitimacy through their parentage. The genealogies of Jesus enumerated in Matthew and Luke (the latter of which does not mention Abiud) inspired the medieval convention of representing his forebears in many locations, from the facades of churches to miniatures in manuscripts. The columnar figures of sculpted ancestors that frequently flank church doorways appear literally as well as metaphorically to hold up the church. Like them, this Abiud was part of a cycle of ancestors, although such cycles were not often produced in stained glass.

The biblical genealogies of Jesus place him in the lines of Abraham and King David, and all his ancestors were Jewish. Abiud's pointed green hat identifies him as a Jew. Pointy hats of various styles were a signifier of Jewish identity; they were first used to identify Jews in art in the eleventh century, before European Jews commonly wore them. The Cloisters Cross (entry 12) includes another variant on the shape of the hat. While the hat did signify "otherness," something outside Christianity, it was not inherently pejorative; in this stained-glass panel, it is encircled by a halo, underscoring that point and positively associating the Old Law of Moses with the foundation of Christianity. Similarly, the pointed hat appears in some Hebrew manuscripts, identifying Jewish figures without condemnation. However, in other Christian works, such as the Cloisters Cross, and in other contexts from the same period and later, pointed hats mark Jews as the enemies of Christ and reflect localized sentiment against them.

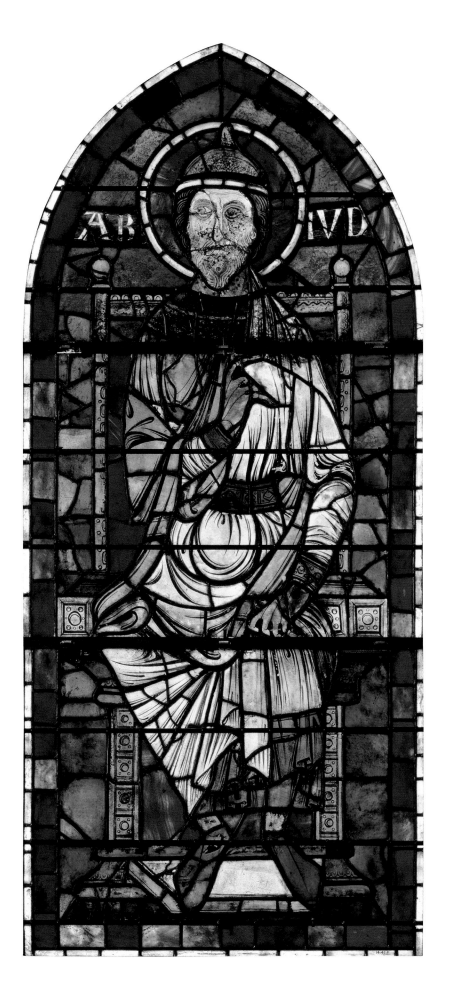

Joshua and David, from the Nine Heroes Tapestries (detail)

South Netherlandish, ca. 1400–1410
Wool warp and wefts, overall 14 ft. x 20 ft. 10 in. (42.67 x 63.5 m)
Munsey Fund, 1932; Gift of John D. Rockefeller Jr., 1947; Gift of George A. Douglass, 1947
(32.130.3b; 47.101.1; 47.152)

The set of tapestries at The Met Cloisters celebrating the Nine Heroes (three Hebrew, three Christian, and three classical) is a remarkable survivor from about 1400, an early period of monumental wall hangings. The two large figures in this reconstructed tapestry, the most complete of the set, are heroes from the Hebrew Bible, David and Joshua. David is identified by the harp on his coat of arms, a reference to his playing the harp as a youth to soothe King Saul. Shown as a bearded king, David holds a book representing the Book of Psalms, which he reputedly authored, and a sword distinguishing him as a warrior for Israel. The bejeweled cloak lined with ermine accords with his kingship.

Joshua's coat of arms is emblazoned with a winged dragon, or wyvern; while not as specific as David's harp, the attribute is appropriate for a great chivalric warrior. That identity is reinforced by the smaller figures adjacent to David and Joshua: soldiers and guards carrying fifteenth-century weapons, including a crossbow and a longbow. The knight at the lower left is dressed in plate armor and a mail shirt.

The subject of the Nine Heroes derives from a poem written in 1312 that identifies three classical heroes (Hector of Troy, Alexander the Great, and Julius Caesar), three Christian heroes (King Arthur, Charlemagne, and Godfrey of Bouillon), and three Hebrew heroes (Joshua, David, and Judas Maccabeus) as paragons of wisdom, valor, and chivalry. The heroes, or worthies, as they are also called, were considered models for the behavior of a medieval prince. That three figures from the Hebrew Bible are given equal treatment to those from the ancient and Christian eras is testament to the high regard and sense of cultural continuity expressed by Christians in the Middle Ages toward the Old Testament.

Each of the heroes is enthroned in a niche within colorful Gothic architecture. The setting is remarkably

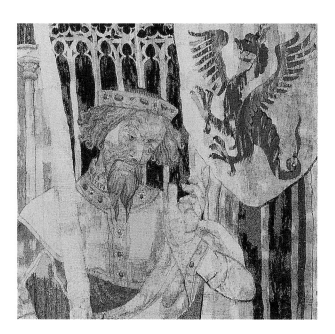

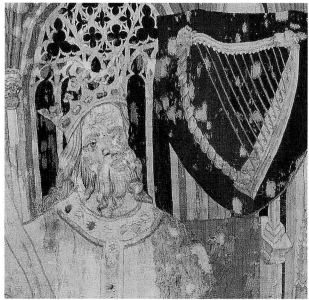

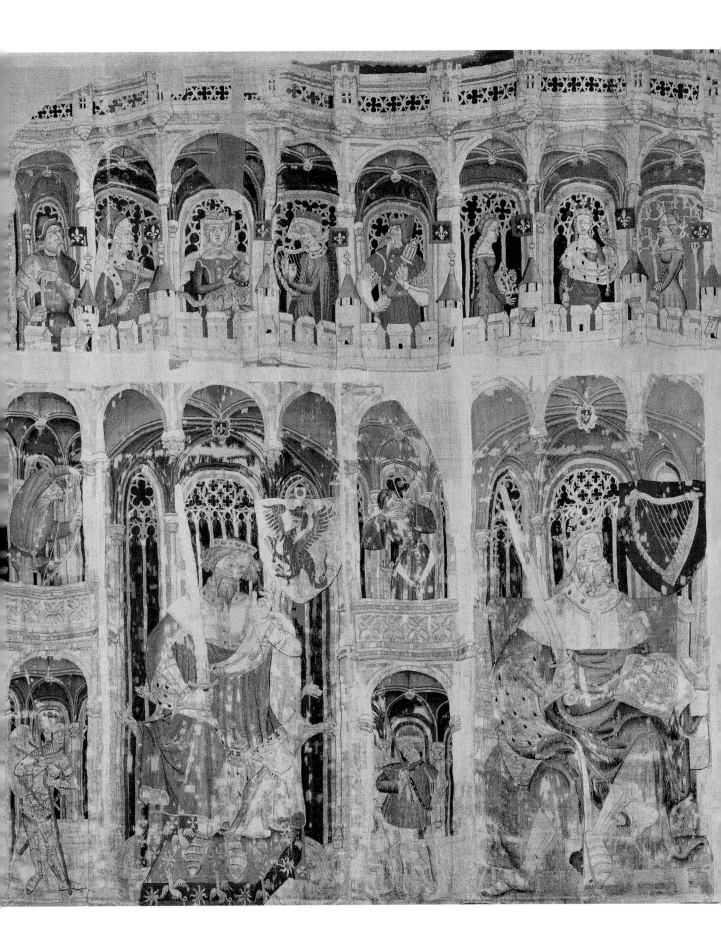

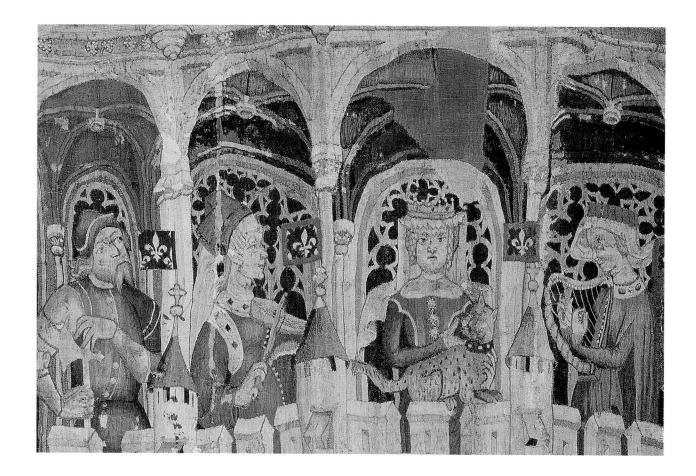

detailed, with openwork tracery behind the figures and vaulting above in shades of red and blue. Crenellations and small turrets separate the lower zone of heroes from an upper band of smaller secondary figures. That upper row is among the best-preserved parts of the tapestry and retains its original clarity and brightness of color. It depicts Joshua's and King David's courtiers, not garbed as they would have been in the first millennium B.C. but richly adorned in the fashion of the early 1400s. Sleeves with decorative edging, ermine wraps, and elaborately braided hairdos are among the details that mirror the styles of the court of the original owner, likely Jean de France, duc de Berry. One lady strokes a pet cheetah, another carries a falcon, while others play a harp and a viol. These marginal figures contribute to the sense of collapsed time, the fusing of past and present typical of medieval art and thought, which saw no contradiction in representing biblical heroes and their followers as French courtiers.

The set of three horizontal tapestries (each originally measuring at least sixteen feet by twenty-one feet) served as both practical insulation and colorful decoration for a drafty medieval castle and as an ostentatious demonstration of wealth. Tapestries on this scale were expensive; highly labor intensive, they took entire workshops of weavers months or years to complete. This set was cut up at some point, and some of the pieces were sewn into window curtains with red linings. When the Metropolitan Museum acquired the pieces, the backing was painstakingly removed and the resulting ninety-odd fragments were reassembled in the original arrangement, using modern tapestry cloth to fill in gaps in the composition. Even in their incomplete state, the tapestries demonstrate the highest level of courtly interior decoration and provide a characteristically medieval illustration of ancient heroes as contemporary kings.

Miniature Shrine

South Netherlandish, 1500–1525
Boxwood, 5⅞ x 3 x 1¼ in. (15 x 7.6 x 3.2 cm)
Gift of J. Pierpont Morgan, 1917 (17.190.453)

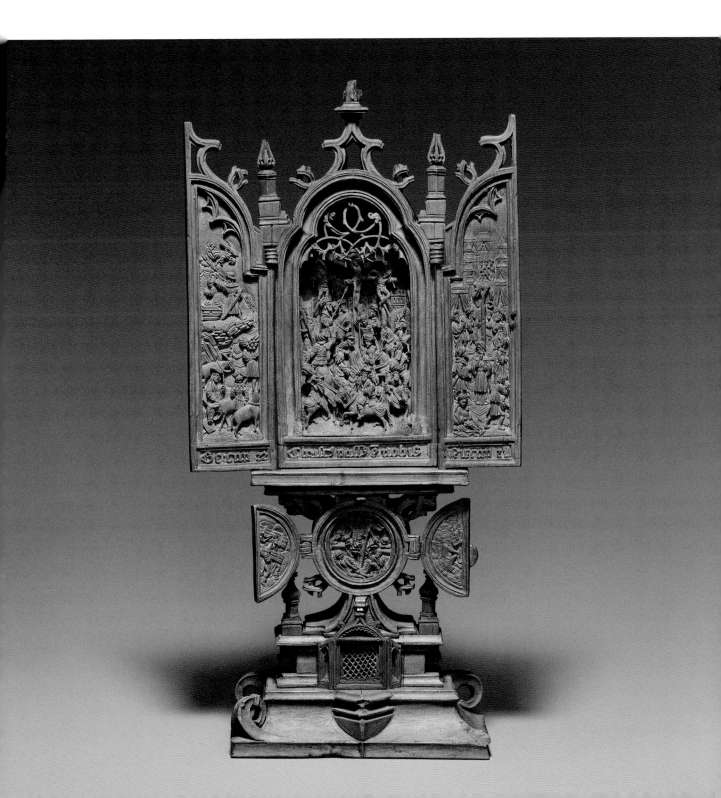

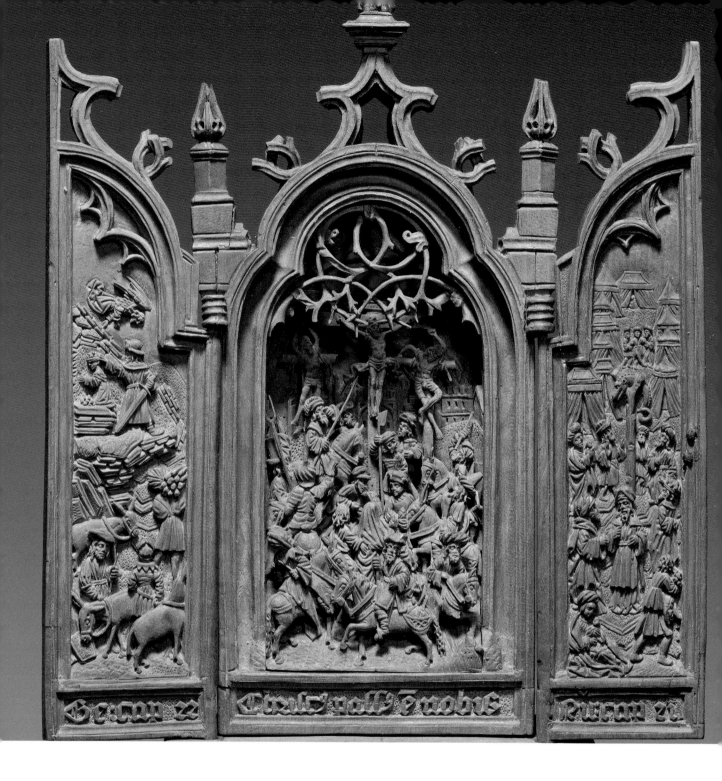

Boxwood's hardness and density made it possible for this miniature shrine to be carved with minute precision; details such as the spears are even fashioned in the round, although no bigger than a pin. The object is composed of two triptychs, one mounted on top of the other. The structure resembles a monumental altarpiece yet is only about the size of a woman's hand.

This little shrine is an excellent illustration of prefiguration, a key to medieval Christians' understanding of the Hebrew Bible. Prefiguration is the interpretation of persons or events in the Old Testament as prophesies of those in the New Testament. In medieval art, the stories of the Hebrew Bible were usually made to serve a Christian purpose, showing how the older Bible could

be read to symbolize, or prefigure, the new one. The influential theologian Saint Augustine (354–430) articulated the concept: "Novum Testamentum in Vetere latet; Vetus in Novo patet" (The New Testament is hidden in the Old; the Old is made clear by the New).

The upper central scene here, the Crucifixion, is deeply carved in an arched niche ornamented with delicate openwork tracery, with eighteen figures and seven horses in an area smaller than a playing card. On the wings are two scenes from the Hebrew Bible said to prefigure the event. On the left is the Sacrifice of Abraham, in which God asked Abraham to sacrifice his son Isaac, just as God would sacrifice his own son on the cross. The story is told in a vertical composition from the bottom up, with Abraham's two servants watching over the donkeys while Isaac, seen from behind just above them, carries wood for the sacrificial altar up the mountain. In the climactic scene at the top, Isaac kneels on the altar, Abraham touches his son's head with one hand while wielding a huge sword with the other, and an angel flies down at the last moment to stop him. The right wing shows Moses and the Brazen Serpent, from the Book of Numbers. The text describes the Israelites wandering in the desert and complaining to God and Moses, causing a wrathful God to send fiery serpents. The chastened Israelites repent and ask Moses to pray to God on their behalf. God instructs him to create a bronze serpent and raise it on a pole, as seen here, so that all those bitten by the fiery serpents can see it and be saved. According to the Gospel of John, Jesus himself cited this tale as prefiguring his crucifixion, implicitly comparing salvation gained by gazing at the elevated bronze serpent to that earned by contemplating him upon the cross.

The central medallion of the lower triptych represents the Resurrection. Christ steps forcefully from his tomb carrying a cross-topped staff and banner, while four soldiers sleep in the four quadrants of the circle, all within an area the size of a dime. The semicircular left wing depicts a large bearded man carrying two doors. This is Samson carrying the doors of Gaza, which he has broken, thus escaping the enemies who had sought to kill him. The broken doors echo the broken gates of hell in the Descent into Limbo, the scene with which the Orthodox Church represents the Resurrection, or Anastasis (see entry 6). On the right wing, a naked man, his hands in prayer, emerges from the toothy jaws of a sea monster. This is Jonah, whose disobedience God punished by having him swallowed by a great fish. He was spewed forth after praying for three days from inside its belly. The Gospels record Jesus citing Jonah's story as a prefiguration of his three days of entombment between his crucifixion and resurrection.

In this virtuosic display of miniaturization, two key scenes of the Christological cycle are thus shown in the context of four dramatic stories drawn from the Hebrew Bible. While the representation of the older stories as archetypes that prefigure events in the New Testament emphasizes the unity of the two testaments, it intrinsically diminishes the Hebrew Bible by viewing it only through the lens of Christianity.

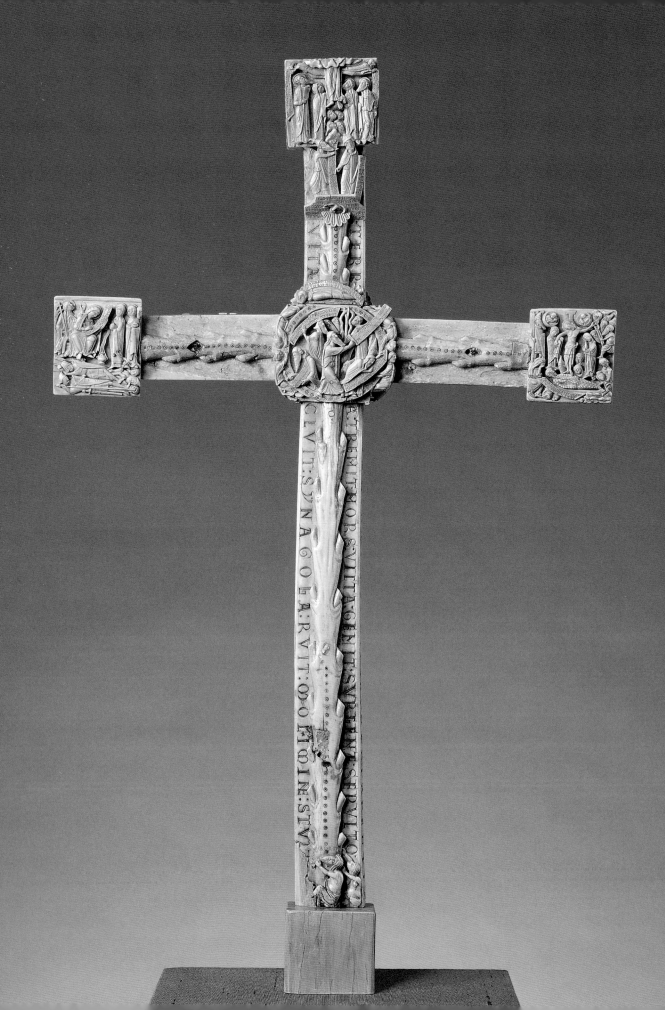

The Cloisters Cross

British, ca. 1150–60
Walrus ivory, 22⅝ x 14¼ in. (57.5 x 36.2 cm), Diam. of central medallion 2⅝ in. (6.7 cm)
The Cloisters Collection, 1963 (63.12)

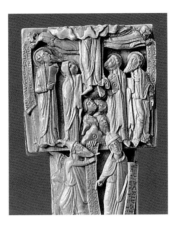

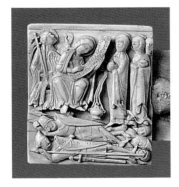
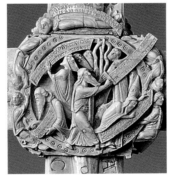
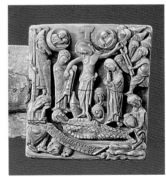

This ivory cross is a complex and supremely accomplished work of art, carved from five pieces of walrus tusk fitted together. Its ingenious creator covered its surface with more than ninety figures, scenes, and inscriptions in tiny scale, epitomizing a high standard of technical skill while also presenting a scholarly theological program. Some of the scenes portray immediately legible and easily recognizable incidents of the Christ story; others challenge interpretation to this day.

Originally the object would have had a corpus, or figure of the dead Jesus, attached to the front. The terminals, square plaques at the cross's ends, each only about two inches square, show Post-Crucifixion scenes. The right terminal presents Jesus being removed from the cross, flanked by a grieving Mary and John. This Deposition is accompanied in the same terminal by a group of mourning figures around the shrouded, prostrate figure of Jesus on his tomb—a Lamentation scene. On the left terminal, holy women approach an angel holding a scroll, while soldiers sleep below. Squeezed into the upper left of this plaque is the Resurrection, recognizable by the figure of Christ holding a cross staff as he looks and gestures upward. The square plaque terminating the top of the cross shows the Ascension: a group of figures looks up toward Christ, who is rising to heaven. Only his legs and feet remain in view as he disappears into a cloud. Just

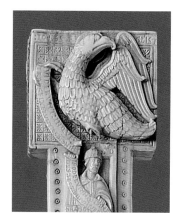

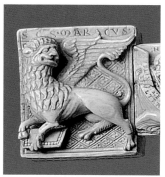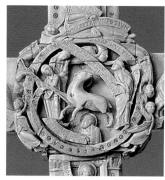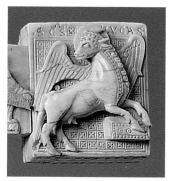

below the Ascension are two figures holding scrolls. The one on the left wears a pointed hat that identifies him as a Jew (see entry 9). He is Caiaphas, the high priest who condemned Jesus, here arguing with Pontius Pilate. The round central medallion, which would have served as the halo for the corpus of Jesus, illustrates the story of Moses with the Brazen Serpent (described in entry 11), which Jesus cited as prefiguring his crucifixion.

Prophets from the Hebrew Bible fill the arms and shaft on the reverse of the cross. They bear scrolls inscribed with passages that have been interpreted as foretelling the Crucifixion. The three square terminals on this side of the cross display symbols of the Evangelists (see entry 16): the lion of Mark, the eagle of John, and the ox of Luke; the fourth symbol, the angel of Matthew, would have appeared on the now-lost terminal at the bottom. The central medallion on the rear of the cross portrays the Lamb of God, an epithet and metaphor for Jesus. That symbolic image is pierced by a lance held by Synagoga, the personification of Judaism, depicted as a veiled woman turning away. Just behind her stands the weeping figure of John, the youngest apostle. This allegorical, nonbiblical scene reflects the distinctly anti-Jewish tenor of some of

the cross's many Latin inscriptions. One translates in part as: "The Jews laughed at the pain of God dying."

The Cloisters Cross is a work of Christian art made for a Christian audience, with a comprehensive didactic program about the Crucifixion, but its message was not directed at the general public. This cross is a liturgical object made for the altar of a church, and only the local clergy would have had the privilege of examining it closely enough to discern its diminutive texts and imagery. However, its complex iconography clearly reflects disputes between Jews and Christians as well as the anti-Jewish sentiment and violence against Jews that were on the rise in England when the cross was created, in the latter years of the twelfth century, culminating with an edict to expel the Jews in 1290.

While the Cloisters Cross documents an ugly history of negative attitudes toward Jews, it is also an ivory carving of great beauty and consummate skill that ingeniously fits dense and expressive narrative details into compact compositions. Viewing these energetic and individuated figures in close-up photography, it is easy to forget that each is smaller than a matchstick and was fashioned in an age before magnification.

Master of the Barbo Missal (Italian, 15th century)

Mishneh Torah

North Italian, ca. 1457
Tempera and gold leaf on parchment, leather binding, each folio 9 × 7¼ in. (22.7 × 18.4 cm); 346 leaves
Jointly owned by The Israel Museum, Jerusalem, and The Metropolitan Museum of Art, New York, 2013.
Purchased for The Israel Museum through the generosity of an anonymous donor; René and Susanne Braginsky, Zurich; Renée and Lester Crown, Chicago; Schusterman Foundation, Israel; and Judy and Michael Steinhardt, New York. Purchased for The Metropolitan Museum of Art with Director's Funds and Judy and Michael Steinhardt Gift (2013.495)

This exceptionally beautiful Hebrew manuscript is a rare survivor, a luxury item made for a Jewish patron in the late Middle Ages–early Renaissance. A copy of a rabbinical text by a great medieval scholar, it is the most richly ornamented copy known to exist of an important book of Jewish law. Its lavish illustrations include many figures. Although art made for Jewish patrons usually avoids figural representation in adherence to the Mosaic prohibition of idolatry (the worship of graven images), exceptions exist throughout history. Nevertheless, a Jewish law manuscript so opulently painted with scenes of human detail and anecdotal charm is exceedingly rare.

The text was written by the Jewish rabbi, scholar, and philosopher Moses Maimonides (1135–1204) approximately three hundred years before this manuscript was created. Maimonides's text was considered the definitive compendium of Jewish law. It anthologized more than a millennium of legal doctrine, including passages from the Hebrew Bible and the Talmud, a vast collection of ancient rabbinic writing and oral commentaries. Its name, Mishneh Torah, means restatement or repetition of the Torah (Law). It remains an authoritative text. This particular manuscript includes the last eight of the fourteen books of the Mishneh Torah, whose topics include agricultural law; rules concerning sacrifices, ritual purity, and temple service; and criminal and civil law.

The manuscript is illustrated with miniatures, illuminated text blocks, and six full-page narrative compositions, frontispieces to divisions of the text, with large Hebrew letters in burnished gold spelling out the titles. The gold letters float on an intense blue background

decorated with white filigree, signifying the sky, which hovers over lively scenes set in flowering landscapes of vivid green. Characters in attire typical of the mid-fifteenth century participate in activities that relate to the legal concepts addressed in the accompanying text.

Property law is the subject of the Book of Acquisitions, which opens with folio 205v (see pages 44–45). The animated scene shows two commercial transactions, the sale of a house on the left and the purchase of a horse on the right. The frontispiece of the Book of Temple Service (fol. 41v, following page) features two men performing ritual sacrifices on either side of a large domed octagonal building, a conventional representation of the Temple of Jerusalem. The figure on the left tends the burning of an offering on an altar pedestal, while the one on the right ceremoniously cuts the throat of a sacrificial calf. The Book of Judges (fol. 306v, page 63) opens with a composition in two parts, separated by the bold Hebrew letters of the title. The upper register presents two rulers astride brightly caparisoned horses charging one another, smashed lances at their feet. The lively representation of a contemporary courtly joust is meant to evoke warfare, one of the topics covered in the book. In the lower scene, four judges sit on a bench, interviewing a suspect who is held by two men.

Details, from the horses' splendid trappings to the wattle fence in the landscape, reflect the artist's observant eye. As no other Mishneh Torah with such complex illustrations is known to exist, the artist likely was not working from an established visual iconography. Instead, he probably followed verbal instructions from a scholar

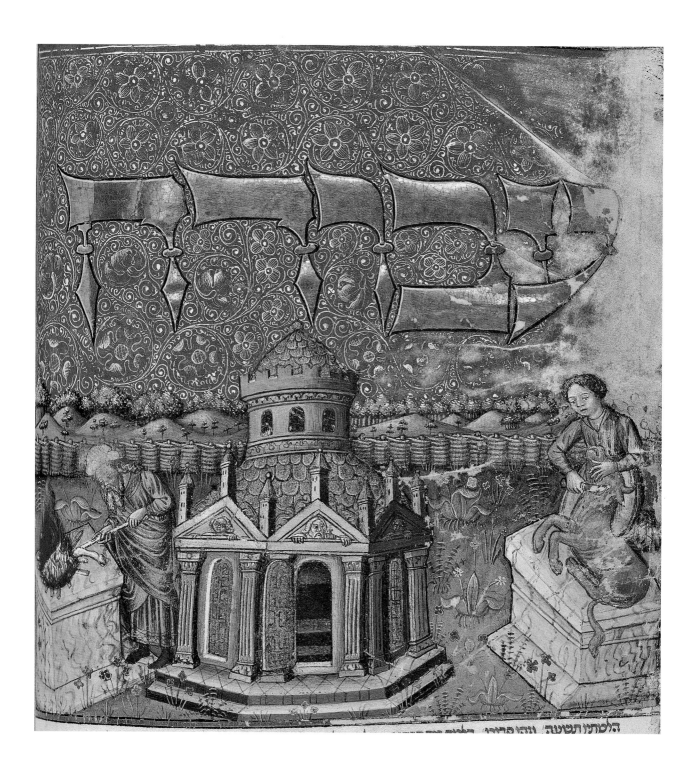

הלכות נטיעה ווהו פרחו

familiar with the text and elaborated the scenes with details from contemporary life, art, and costume. The manuscript has been attributed on stylistic grounds (including the bright palette and decorative landscapes) to an artist known as the Master of the Barbo Missal. Although his proper name is unknown, his hand is recognizable in a number of manuscripts made for Christian patrons. Thus it appears that Jewish connoisseurs living in Italy in the fifteenth century had the means and the desire to commission this book from an artist who had worked for dukes and cardinals—and that an artist accustomed to depicting a standard repertoire of Christian stories had the ability to turn his invention to an entirely new set of scenes illustrating Jewish law.

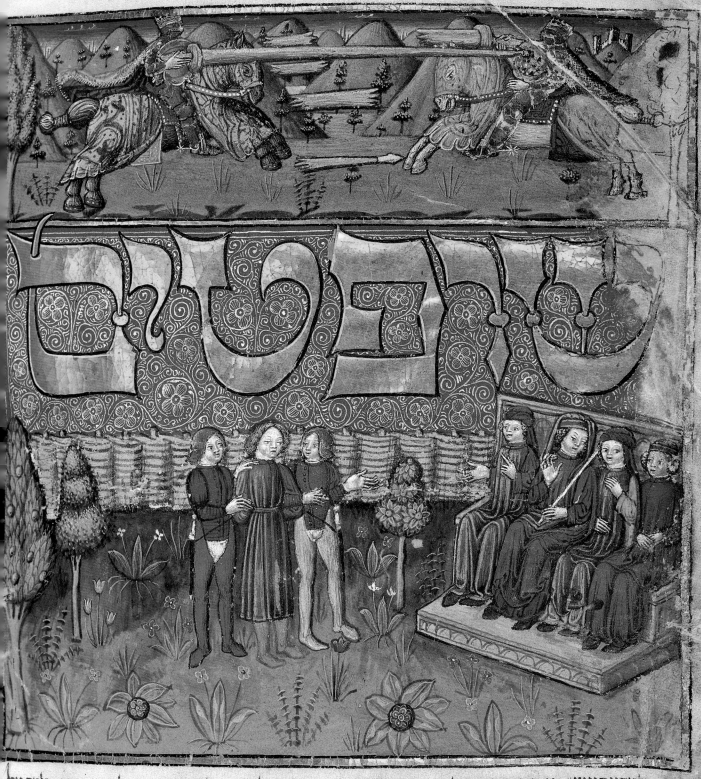

אהבה

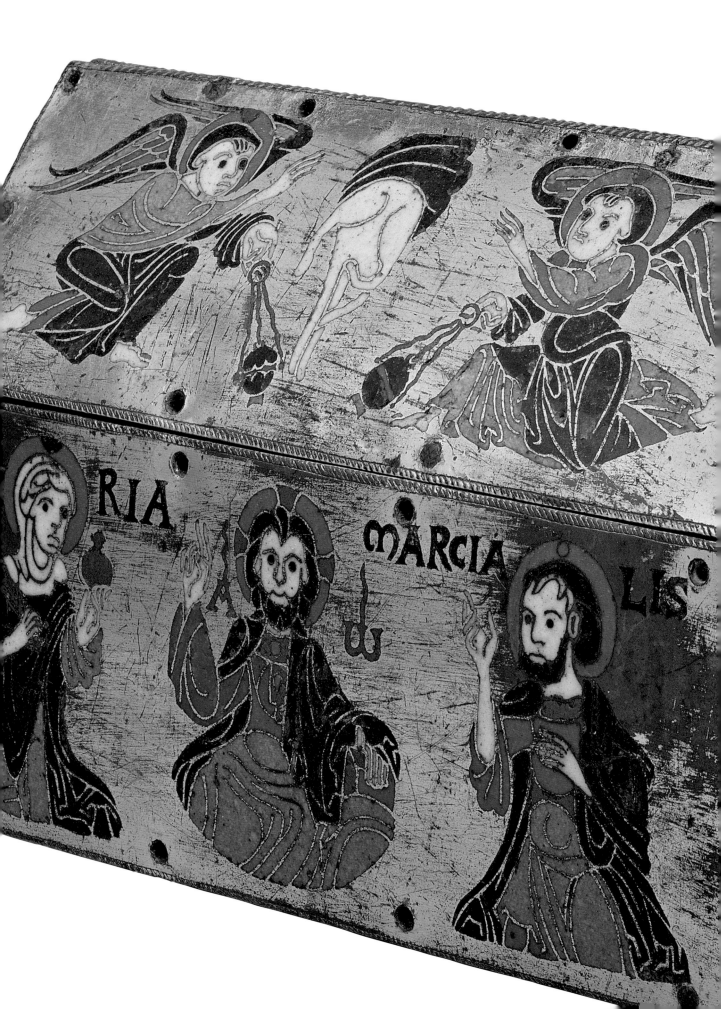

SAINTS AND THEIR ATTRIBUTES

Master of James IV of Scotland (probably Gerard Horenbout,
South Netherlandish, active ca. 1485–1530)

Saint John the Baptist with Scenes from His Life

South Netherlandish, Bruges, ca. 1515
Tempera, ink, and gold on parchment, 6½ x 4⅝ in. (16.5 x 11.7 cm)
Bequest of George D. Pratt, 1935 (48.149.16)

John the Baptist is a key figure in all four Gospels, one of the most important saints in Christianity, and one of the saints most often represented in art. This remarkable page, probably from a luxurious Book of Hours, centers on a portrait of the saint in a pastoral landscape, surrounded by scenes from his life and death. He is shown performing his defining act, baptizing Jesus, in the upper left border.

According to biblical accounts, the two first met when both were in the womb, John leaping in recognition of Jesus's divinity during the Visitation (see entry 1). Nonbiblical sources, such as *Antiquities of the Jews*, by the first-century Jewish historian Josephus, attest to the saint's historical existence. As an adult, John was a messianic itinerant preacher, living in the wilderness and offering baptism for the forgiveness of sins. Ritual ablution was common to many Roman-era religious sects.

In the main scene, John can be identified by two key attributes (visual clues consistently associated with him): a hairy garment and a lamb. The first refers to his years in the desert clothed in camel's hair; the latter to a common sacrificial animal in pagan and Jewish rituals. A Gospel passage recounts that when John saw Jesus approaching, he said, "Behold the Lamb of God," referring to Christ's ultimate sacrifice. In medieval art, a lamb sometimes stands in for Jesus (see fig. 15); a man carrying or accompanied by a lamb signifies John the Baptist. The diminutive scenes in the border chronicle the saint's life. As John baptizes Jesus, the dove of the Holy Spirit hovers in a golden radiance, bearing witness to Jesus's divinity. The other scenes show John preaching; his arrest and imprisonment; his head delivered on a platter to Salome; Herod's feast; and the burning of John's bones.

Similarly, John can be recognized by both the hairy garment he wears and by the action of baptizing Jesus in a richly painted and gilded narrative relief, the wing of a monumental, now-lost altarpiece (fig. 13). He raises his right hand in blessing over Jesus, who stands in the river Jordan, his hands in prayer. The angel at the right carries a golden robe in which to dress Jesus after his ritual immersion. Thus both these works illustrate the two ways to depict a saint, with a static "portrait" identified with attributes, and with narrative scenes from his or her life and legend.

Figure 13. Workshop of Veit Stoss (German, ca. 1445–1533). The Baptism of Christ. German, Nuremberg, ca. 1480–90. Limewood with paint and gilding, 48 x 40 x 3 in. (121.9 x 101.6 x 7.6 cm). Rogers Fund, 1912 (12.130.1)

ΕΚΤΟΥΚΑΤΑ ΜΑΘΘΑΙΟΝ

ιτωβρὸκέτόρα
τὲμηκαταφρο
μησητεβμὸς
τὼμμιερωρτού
των †ίδρογαρὶ

μὴν + ὅτιοιἁγγελοι
αὐτῶμβριὁιωῶοις
διαπαντὸσωρβ
ωσυσιτὸπρόσω
πομτουῶρόσμου

Saint Matthew, from the Jaharis Byzantine Lectionary

Byzantine, Constantinople, ca. 1100
Tempera, ink, and gold on parchment, 13¾ x 10⅜ in. (35 x 26.2 cm)
Purchase, Mary and Michael Jaharis Gift and Lila Acheson Wallace Gift, 2007 (2007.286)

Four important early saints frequently found in medieval art are the Evangelists who wrote the Gospels: Matthew, Mark, Luke, and John. Depictions of the Evangelists often serve as frontispieces to their texts and other liturgical books, much as photographs of authors are featured on book jackets today. Although they are called Evangelist portraits, they do not attempt to show the actual appearance of first-century individuals but rather reflect ancient precedents and later stylistic conventions.

The most common type, seen in this image of Matthew (fol. 43r) from a luxurious Byzantine manuscript, continues an antique tradition of the philosopher portrait, showing the saint seated before his text wearing classical garb. Examples in manuscripts of this type of portrait, used for both pagan and Christian writers, survive from as early as the fifth century. Evangelist portraits of this type are common throughout the Middle Ages and later, and continue to be made to the present day.

The survival of antique traditions is evident in this manuscript illumination. Although the gold background and pastel-colored architecture appear flattened, Matthew's body and facial features are subtly modeled with color to give a sense of volume. Not only his garments but also the lectern before him and the draped doorway behind him are based on ancient examples. The lectern stands on a cabinet filled with writing implements, including an inkwell. Befitting his work as a writer, Matthew holds a pen in his right hand, inspecting its point; a knife for sharpening it is in his left hand, which rests on his knee. While he gazes at his pen, he simultaneously seems to attend to the hand of God, which emerges from a blue hemisphere above, as if providing inspiration for his writing.

This portrait is in a lectionary, a book of Gospel readings arranged in the sequence of the liturgical year. While most Evangelist portraits appear in manuscripts, they can be found in other media, such as a carved ivory plaque (fig. 14) that might have been attached to a book cover or otherwise grouped with portraits of the other Evangelists. In type and composition, the depiction of Saint John on the ivory closely relates to images of the Evangelists in manuscripts of the same period, early in the Carolingian Empire of western Europe. The seated saint displays his book with its opening text: "In principio erat verbum" (In the beginning was the word). His voluminous drapery, while based on antique prototypes, displays decorative flourishes characteristic of local Carolingian style. Classical architecture is evoked in the carved columns, capitals, and archway that frame the figure. Above the figure's head is an eagle holding a book in its wings, John's Evangelist symbol (see entry 16).

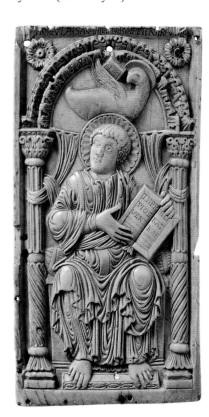

Figure 14. Plaque with Saint John the Evangelist. Carolingian, Germany, Aachen, early 9th century. Elephant ivory, 7¼ x 3¾ x ¼ in. (18.3 x 9.4 x 0.7 cm). The Cloisters Collection, 1977 (1977.421)

Chasse of Champagnat

French, Limoges, ca. 1150
Engraved and gilded copper and champlevé enamel, 4⅞ x 7½ x 3⅜ in. (12.4 x 18.9 x 8.5 cm)
Gift of J. Pierpont Morgan, 1917 (17.190.685–.687, .695, .710, .711)

The symbols of the four Evangelists dance in brilliant colored enamel across this little copper box produced in Limoges, a great center of enamel production. They are the winged man, or angel (for Matthew), the lion (Mark), the ox or calf (Luke), and the eagle (John).

Saint Jerome (ca. 345–420), who translated the Bible into Latin from Greek, Hebrew, and Aramaic, first associated the four creatures with their respective Evangelists in his prologue to the Gospels. He drew upon references to the creatures in Ezekiel in the Hebrew Bible and the Book of Revelation in the New Testament. As early as the beginning of the fifth century, mosaics in churches in Rome included the four creatures as winged bust-length figures. The symbols were represented in gospel books at least as early as the sixth century and appeared later in monumental form on numerous medieval church portals. They sometimes accompany portraits of the Evangelists, where they serve as a visual label, and also appear independently, as they do here (see also, for example, entries 2, 12). They continue to be depicted to the present day, most often shown as they are here, winged, haloed, and holding books or scrolls.

On this gabled copper box, or chasse, the angel of Matthew holds his red book in veiled hands, a sign of respect. The eagle, lion, and ox turn their heads toward the center, while their bodies twist away. Their varied feet—toes, talons, claws, hooves—are fully differentiated. The central foliate ornament springs from two fanciful creatures with human heads and birds' bodies. The brilliant blue, green, and red of the enamels enhance the designs' lively character. Champlevé enamel is produced by carving into the metal base, creating little basins with raised edges that form the outlines of the design when the basins are filled with ground colored glass and fired.

The chasse originally contained a relic of a saint. Relics, the revered physical remnants of the holy or their belongings, were believed to have the power to direct the prayers of the worshiper to that saint in heaven. The reliquary not only protected the relic; it also honored and projected the power of its sacred contents through its fine manufacture, glittering decoration, and skillful representation of holy figures and potent symbols.

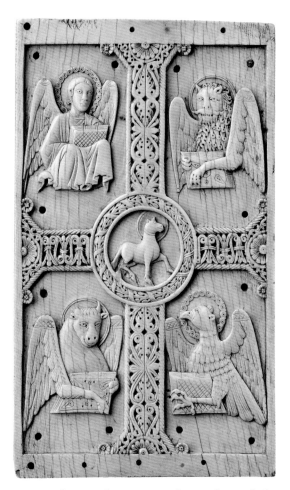

Figure 15. Plaque with Agnus Dei and Evangelist Symbols. South Italian, Benevento (?), 1000–1050. Ivory, 9¼ x 5⅜ x ⅜ in. (23.5 x 13.7 x 0.9 cm). Gift of J. Pierpont Morgan, 1917 (17.190.38)

The four Evangelist symbols also appear on a southern Italian ivory plaque (fig. 15), which once may have decorated the cover of a luxury gospel book to proclaim its authors. Each creature is shown here as a half-length bust with feathered wings, a halo, and a book. The faces are delightfully expressive, especially those of the mustachioed lion and the smiling ox. The haloes of the angel and eagle are rimmed in a pattern of circles, and their books are scored with lines; the lion and ox have simpler haloes, and their book covers are decorated with circular designs. The prancing animal in the central medallion represents the Agnus Dei, the Lamb of God (see entry 14), here symbolizing Christ. The quality of the carving brings vitality to the individual figures and richness to the varied foliate patterns filling the cross and circling the lamb.

Representations of the four Evangelist symbols are ubiquitous in the art of the Middle Ages and common in Christian art of later centuries. Recognizing them in their various forms can be one of the pleasures of exploring medieval art.

Christ with Saints Peter and Paul

German, Westphalia, ca. 1150–1200
Elephant ivory, 6 x 3⅜ x ⅜ in. (15.1 x 8.5 x 0.9 cm)
The Cloisters Collection, 1979 (1979.399)

Peter and Paul, both apostles of Jesus, were crucial in establishing Christianity after his death and are among the religion's most important and most frequently represented saints. Introduced here by this twelfth-century German ivory carving, where they flank the figure of Christ, they can be recognized by the objects they hold and by their facial appearance. Peter, a fisherman in Galilee, was one of Jesus's first followers. He can be seen in scenes of the Arrest, where he cuts off the ear of Malchus, one of the mob present at Jesus's capture (see entries 2, 5). After the Crucifixion, he was the chief apostle to the Jews. Paul was not a disciple during Jesus's lifetime. He is introduced in the fifth book of the New Testament, the Acts of the Apostles, as Saul, an oppressor of Christians. Saul is struck blind by a divine light and hears the voice of Christ challenging his aggression, inspiring him to convert and change his name. As Paul, he became the most effective champion of Christianity outside the Jewish community, the apostle to the gentiles.

The representation of the saints in this ivory is symbolic, outside of time and space, emphasizing that their power flows directly from Christ. Christ stands on the dome of a building representing the church, elevated above Peter and Paul, holding two giant keys in one hand and a scroll in the other. (The inscriptions are later additions.) Peter and Paul raise veiled hands to receive the objects, symbols of their authority. On the left Peter reaches toward the keys to the kingdom of heaven; as recounted in the Gospel of Matthew, Jesus rewards Peter with these keys and calls him the rock, the foundation of the church (the basis for Peter's later identification as the first pope of the Roman Catholic Church). The scroll handed to Paul recalls the representation of the *Traditio Legis*, or Giving of the Law, which goes back to Early Christian art. The rendering of the saints' appearance also has deep roots. Works from as early as the fourth century show them with the same characteristics seen here— Peter with a round face, short beard, and curly hair, and Paul with a high forehead and long face.

Those facial types are clearly seen in two Byzantine enamel medallions (fig. 16) from a set of twelve that once adorned the frame of an icon. As these brilliantly colored little disks also show, Peter's curly locks and short beard are light gray (more often white in other representations), while Paul's receding hair and pointed beard are black. These images of Peter and Paul are instantly recognizable without any specific attribute, as distinctive as a portrait of Abraham Lincoln.

 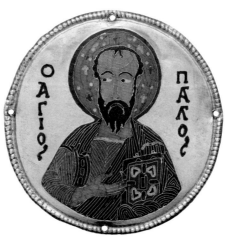

Figure 16. Medallions with Saints Peter and Paul. Byzantine, Constantinople, ca. 1100. Gold, silver, and enamel worked in cloisonné, Diam. 3¼ in. (8.3 cm). Gift of J. Pierpont Morgan, 1917 (17.190.670, .673)

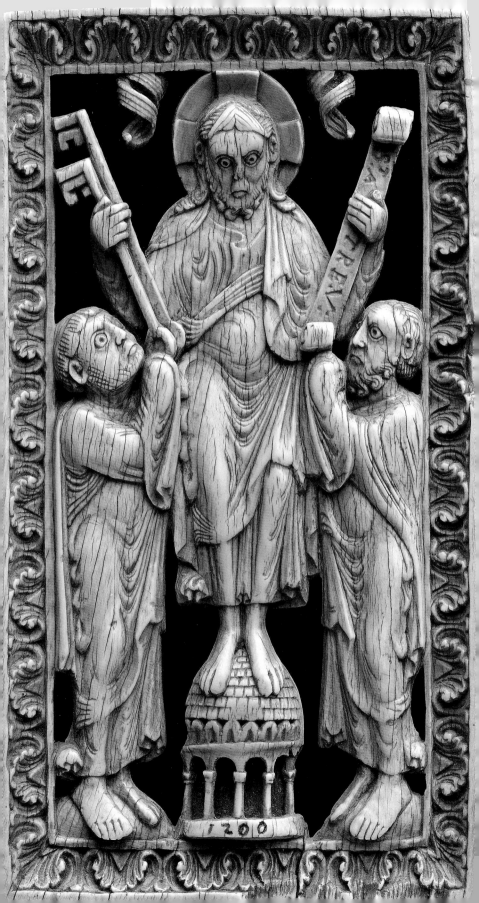

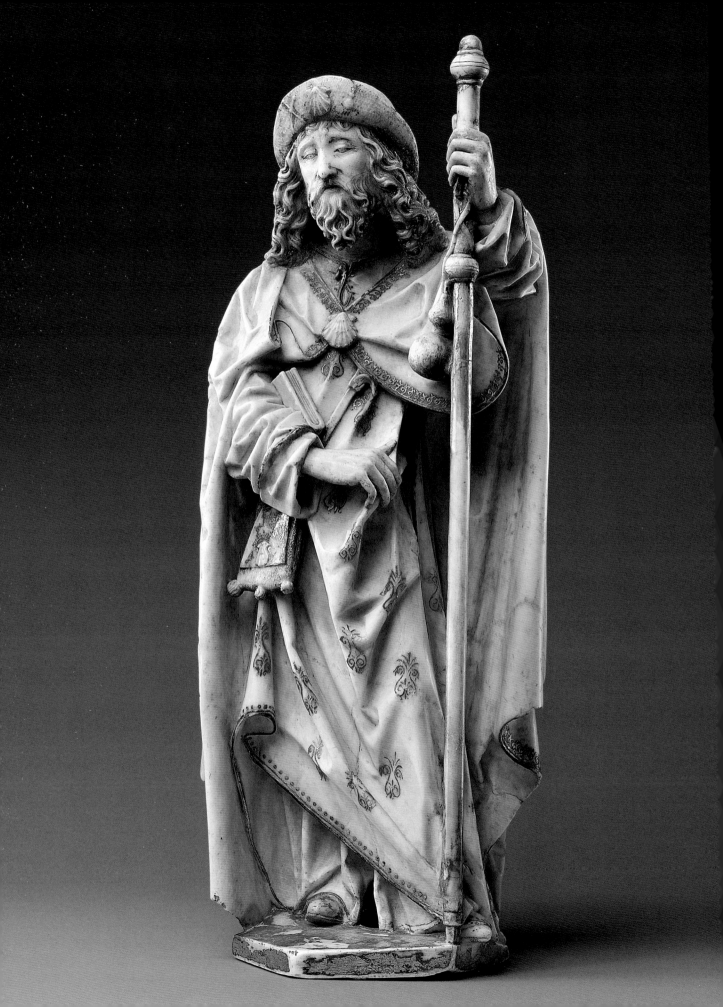

Gil de Siloe (Spanish, active 1475–1505)

Saint James the Greater

Spanish, Castile-León, Burgos, 1489–93
Alabaster with paint and gilding, H. 18⅛ in. (45.9 cm)
The Cloisters Collection, 1969 (69.88)

This alabaster statuette portrays James, a fisherman Jesus called to be a "fisher of men," one of the twelve apostles. After Jesus's death, the apostles were charged to bring his message to the wider world. James's preaching led to his persecution by local authorities, and Herod Agrippa, king of Judea (ruled 41–44), had him beheaded by the sword.

Most saints' attributes relate to their life or the means of their death, but here and in most images of Saint James, he is represented not as a fisherman or martyr of the first century but as a medieval pilgrim. The saint holds a tall walking staff with dangling water gourds and a small satchel or purse, accessories useful on a journey. A scallop shell, James's primary attribute, and crossed staffs ornament his broad-brimmed hat, and shells also adorn his purse and clasp his long, beautifully carved cloak. The saint's finely defined facial features, curling hair, beard, and expressive hands vividly bring him to life. In viewing James as a contemporary, the medieval Christian could identify with the person to whom he prayed; medieval art thus helped the faithful link past and present as they aspired to future glory. This compact statuette, its delicate details enlivened by gilding, was once one of a group of figures on an elaborate tomb.

Saint James's typical representation as a pilgrim reflects the importance during the Middle Ages of pilgrimage to holy sites and the popularity of the route to Santiago de Compostela in northwestern Spain, where James is believed to have been buried. (Santiago derives from Sant' Iago, Spanish for Saint James.) Pilgrimage was a powerful force in the Middle Ages. People walked hundreds of miles to worship in the presence of relics because they had faith that such contact resulted in spiritual rewards. Beginning in the eleventh century, thousands of pilgrims walked, often for months, on the Camino de Santiago (Road to Santiago), and Santiago de Compostela developed into one of the most significant pilgrimage sites in western Europe.

The route was so popular that a guidebook written in the twelfth century described towns along the way, warned about the route's dangers, directed travelers to the best food and safe water, and offered other practical advice. The *Pilgrim's Guide* provides an early surviving literary reference to scallop shells as "the insignia of the blessed James." To this day the shell marks guideposts on the journey and identifies travelers wearing the scallop sign as pilgrims to Santiago, entitled to some food and a place to rest for the night. Pilgrims who reached their goal often obtained a shell-shaped badge, typically made of lead (fig. 17), to memorialize their effort and make the pilgrimage known to others. The faithful readily recognized the badge's scallop shell as signifying Compostela; other sites had their own symbols, such as the crossed keys that stand for Rome (see entry 17). The *Pilgrim's Guide* notes that the souvenirs were for sale in front of the Cathedral of Santiago de Compostela, along with wineskins, shoes, pouches, and other items.

Figure 17. Pilgrim's Badge. French, 15th century. Lead, ⅞ x ⅝ in. (2.1 x 1.4 cm). The Cloisters Collection, 1977 (1977.240.38)

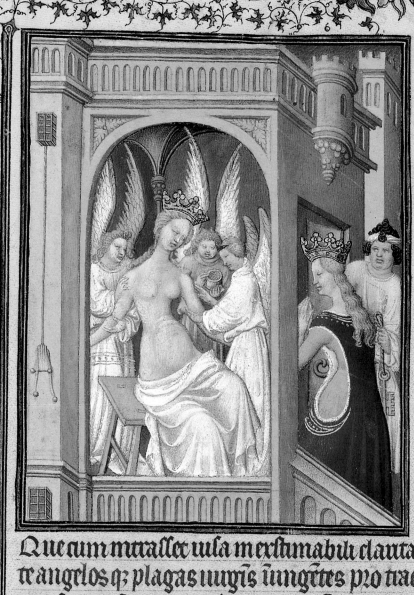

Que cum mtrasset uisa inextimabili clarita
te angelos q; plagas inungis iungetes pro trac
to q; secum sermone usq; ad mediu noctis
de pmys etie uite ad xpi fidem conuersa est

The Limbourg Brothers
(Franco-Netherlandish, active France by 1399–1416)

The Belles Heures of Jean de France, Duc de Berry

French, Paris, 1405–1408/9
Tempera, gold, and ink on vellum, each folio 9⅜ x 6¾ in. (23.8 x 17 cm); 224 leaves
The Cloisters Collection, 1954 (54.1.1a, b)

The *Belles Heures*, a richly decorated Book of Hours (see Introduction and entry 5) and one of the chief treasures of The Cloisters, was made by three young brothers, among the most gifted artists of their time, for one of the greatest medieval bibliophiles, the prince Jean de France, duc de Berry. It is a lavishly illuminated prayer book, with more than 170 paintings of the Nativity and Passion cycles, saints, and other subjects. Unlike other such books, its illuminations include extended narratives laid out like the pages of a picture book, with large framed scenes accompanied by four lines of text. Among the most extensive of these is a cycle of eleven full-page illuminations, three of which are included here, that tell the story of Saint Catherine of Alexandria, who is said to have lived and been martyred at the beginning of the fourth century. The story is excerpted from the *Golden Legend*, a compilation of saints' lives by Jacobus de Voragine (ca. 1230–1298).

The first five scenes establish Catherine as a beautiful and learned princess who ably champions her Christian faith to defeat the arguments of pagan sages assembled by the Roman emperor Maxentius (ruled 306–12). Nonetheless, Maxentius has her tortured and thrown into prison (fol. 17v, opposite). Angels apply soothing balm to her semi-nude (but still crowned) body. The chubby angel in pink holds the jar of ointment, while the one with a blue diadem gently strokes Catherine's arm. The wife of Maxentius, shown as a fashionable medieval queen, peeks in to see the miraculous event; both she and the jailer holding a huge key are converted by the sight. The caption refers to the wondrous light around the saint, and the artists have captured that heavenly glow in the pallor of Catherine's lovely nudity, the white drapery, and the angels' pastel wings.

The next image shown here (fol. 18v, at right) depicts Catherine with her wheel, the instrument of torture that

would become her primary attribute in medieval and later representations. The knives on the wheel were meant for the virgin saint but instead rip through the pagans whose bloodied bodies are caught in its spokes. The kneeling Catherine asks God (at upper left) to destroy the wheel to convert onlookers; three angels at God's side wield claw hammers in answer to her prayer. Catherine is

Figure 18. Saint Catherine of Alexandria. German, ca. 1530. Walnut, 15 x 7¼ x 5¼ in. (38 x 18.3 x 13.3 cm). Gift of Edith Sachs, 1950 (50.64)

ultimately killed by the sword; in the last scene of the cycle, angels in colorful drapery carry her body to its final resting place (fol. 20r, opposite). The gray stone structure tucked between mountain peaks represents Saint Catherine's Monastery, which was built at the foot of Mount Sinai, in Egypt, by the emperor Justinian I (ruled 527–65). The figures at the lower left are recognizable as later medieval pilgrims by their broad-brimmed hats and leather satchels. This scene thus unites the image of a miracle with a view of a real place and wonderfully demonstrates medieval art's conflation of time, showing three eras in one picture: the saint died early in the fourth century, the monastery was built in the sixth century, and it is shown as an important pilgrimage site of the Middle Ages. In this way, the artists conclude Saint Catherine's story by connecting it to the time of the manuscript's creation.

Saint Catherine is rarely accorded such detailed pictorial narration, but the *Belles Heures* cycle provides a basis for understanding other representations. One example is a carved walnut statuette of Catherine that includes many references to incidents in her life and death (fig. 18). The opulently dressed young woman holds an open book, evidence of her breeding and education. Beneath her feet she crushes a bearded male figure, representing her defeat of Maxentius's pagan philosophers. Next to the abject scholar is a broken wheel with knives protruding from its rim, the saint's key attribute. The saint also holds a long sword, the weapon that finally killed her and another attribute. Catherine's costume, especially the ruched sleeves and the headdress, is elaborately detailed, appropriate for her high-born class but perhaps also a direct admonishment to fashionable ladies of the sixteenth century to be as saintly as they are stylish.

Angeli aut corpus eius accipientes ab illo loco
usq̃; ad montē synay itive plusq̃ diierum xx
deduxerunt et ibidē sepeluierit ex aᵘ ossib̃z
idest in ether olei manat infirmitates sanãs.

Roundel with the Temptation of Saint Anthony

German, Swabia, 1532
Colorless glass with vitreous paint and silver stain, Diam. 8 in. (20.3 cm)
The Cloisters Collection, 1982 (1982.433.5)

The large bearded figure in the center of this glass roundel is Saint Anthony Abbot (ca. 250–355). He was a renowned ascetic, a model of solitary monasticism who, inspired by a Gospel passage, gave away his possessions and retreated into the Egyptian desert, where he lived as a hermit, subsisting on bread and water. While Anthony's first biography was written by a contemporary, the primary medieval source of information was Jacobus de Voragine's thirteenth-century *Golden Legend*, which describes Anthony's torment by various animals, monsters, and other strange creatures in some detail. The Temptation of Saint Anthony by devils became a popular subject in late medieval and northern Renaissance art.

The present work illustrating the saint's ordeal is just eight inches in diameter but packed with energy.

Anthony, kneeling, holds a mendicant's bell and a staff topped with the tau, or T-shaped, cross associated with him. He is lifted into the air by monsters who assail him with clubs and claws. These inventive and lively creatures are a chief delight of this piece. The bizarre beast beneath the saint has two faces, an almost human one near his chicken feet and, at the other end, the head of a boar whose jaws pull at Anthony's cloak. The lion-headed monster seems to roar, his mouth a gaping rectangle. The beast near Anthony's head has a snout like a boar, horns like a bull, claws, and wings. A catlike face pokes up by his tongue, above the saint's hat. The monster at the right has no neck, a scaly face, and feathery arms. The devils fit their description in the *Golden Legend*: "They came in the form of divers beasts wild and savage, of whom that one

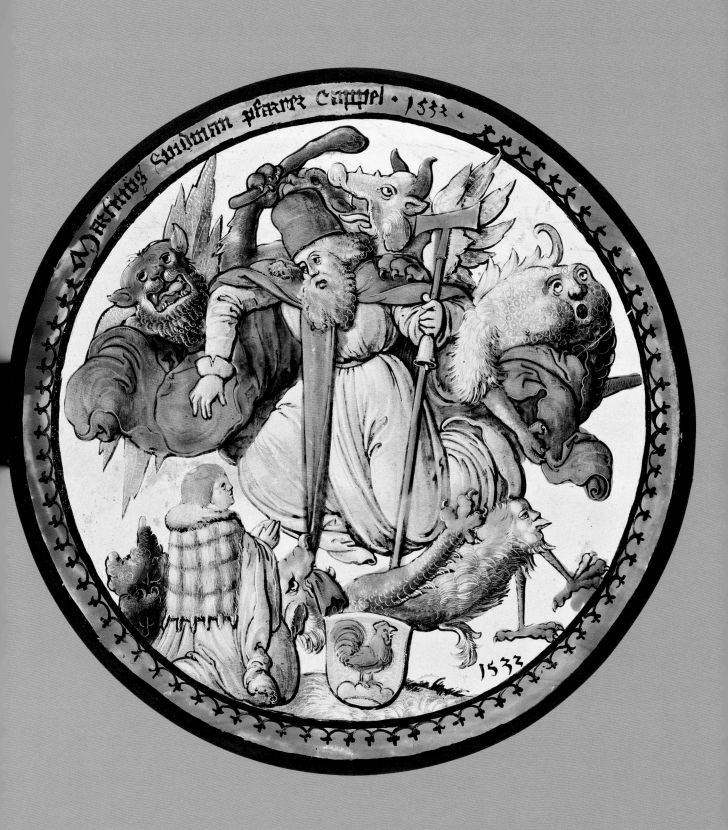

howled, another siffled, and another cried, and another brayed and assailed Saint Anthony, that one with the horns, the others with their teeth, and the others with their paws and ongles."

At the bottom of the glass a man wearing a fur cloak kneels with hands in prayer. His position beneath the main subject and his smaller scale identify him as this work's donor. Medieval art often portrayed donors witnessing holy events that had occurred many centuries before, collapsing time. A donor portrait both credited the individual who commissioned the work and inspired that person to reflect upon the divine event depicted.

Unlike leaded stained glass, in which pieces of colored glass are joined together with lead strips, the design here is uninterrupted by heavy black lines. The Saint Anthony roundel is an example of silver stained glass, in which the image is painted directly onto the reverse of clear glass in black, white, and compounds of silver. The silver can be applied in different levels of intensity, yielding colors ranging from yellow to deep orange when fired.

In static images, Saint Anthony Abbot can be recognized by his attributes rather than by action. In a carved walnut sculpture (fig. 19), the saint has a wonderfully expressive face, with high cheekbones, a small and delicate mouth, and etched wrinkles on his brow and temples. His voluminous hair and beard curl luxuriously. Although the monster at his feet clutches with claws at the saint's robe, Anthony appears calm and disengaged from the struggle. This is a devotional portrait, not a narrative scene. Thus the creature—with a gaping piglike head and a human face on his naked abdomen—functions here as an attribute that identifies the saint as Anthony.

In medieval documents, a depiction in a static, cult, or devotional portraitlike image like this one is known as an *imago.* A narrative depiction, such as in the glass roundel, is termed *istoria.*

Figure 19. Attributed to Nikolaus von Hagenau (German, ca. 1445–died before 1538). Saint Anthony Abbot. Alsace, Strasbourg (present-day France), ca. 1500. Walnut, H. 44¾ in. (113.7 cm). The Cloisters Collection, 1988 (1988.159)

Reliquary Casket of Saint Thomas Becket

British, ca. 1173–80
Gilded silver with niello and a glass cabochon set over a tinted foil, 2¼ x 2¾ x 1⅞ in. (5.5 x 7 x 4.7 cm)
Gift of J. Pierpont Morgan, 1917 (17.190.520)

Small enough to fit in the palm of one hand, this reliquary casket (shown above at actual size) is embellished with images of the martyrdom of Saint Thomas Becket, Archbishop of Canterbury. On December 29, 1170, at twilight, Becket was in the cathedral, preparing for the office of vespers. Four armed knights boldly strode in with swords drawn. There within the sacred ground, near an altar, one knight sliced off the top of Becket's head, but the archbishop continued to stand. Two further blows and he fell to his knees, then was fatally struck again in the head. The murder was recorded in bloody detail in a biography of the saint by Edward Grim, an eyewitness. The event electrified the Christian world. The knights' violence was committed in the mistaken belief that King Henry II of England had wished them to act. For years, antagonism had simmered between Henry and Becket over the relative authority of the church and the crown, and the outrage over Becket's death resulted in posthumous victories: it secured for the church the privileges he had sought and, within three years, Becket's canonization. It was extraordinary for a person to be thus recognized in his own time.

Becket's dramatic martyrdom was soon memorialized in works of art that helped to disseminate the story and teach its lessons. This gilded silver reliquary casket was created immediately following his elevation to sainthood, when living memory of the assassination was still fresh. It is decorated with images of the event rendered in niello, a mixture of minerals used for making designs in black on silver or gold. On the front long side, Becket raises his hands in prayer, while a man wielding a huge

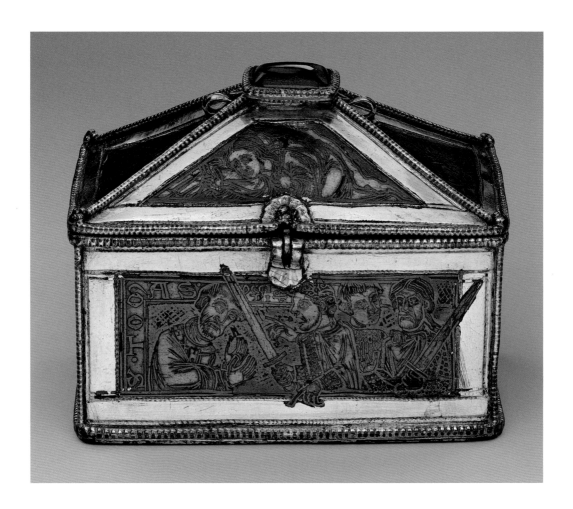

sword strikes the archbishop's head. The soldiers are clothed in mail, and their faces are differentiated in hair and beard. The attackers' two swords extend beyond the frame, emphasizing the scene's violence. Above, on the angled roof, an angel with a sorrowful face blesses the saint. On the back long side, the saint is tenderly held, his eyes closed in death. In the triangular roof space above, an angel holds Becket's soul, presented in the form of an infant. The inscription on this side refers to "sanguis," the saint's blood. Most likely, a drop of blood was the relic this diminutive box originally contained. The red glass set in the pinnacle of the casket would have both drawn attention to and alluded to the hallowed contents of the same color. The intrinsic value of the silver and gilding, to say nothing of the artistry of the niello, were all in service

to the relic, which was surely considered to be more precious than gold.

Becket's assassination is also represented on an ivory liturgical comb created less than a half century after his death (fig. 20). The archbishop falls to his knees as a sword slices into his skull. The figure immediately behind the saint holds out an arm in an attempt to fend off the attack, while his enemies grimly advance. Flanking the scene, two semicircles extend the earthly event to the realms of heaven and hell, an angel on the saint's side and a devil beside the murderers. Priests throughout the Middle Ages used combs for purification rituals before celebrating Mass. The existence of an object such as this one exemplifies both the reverence with which Becket was held soon after his death and his favor among the clergy.

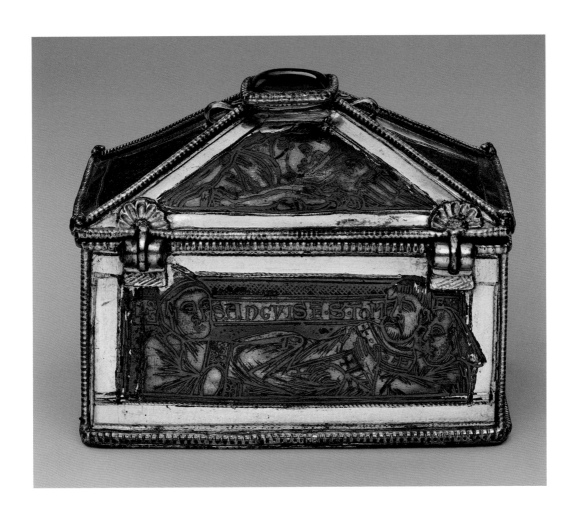

Figure 20. Liturgical Comb with Saint Thomas Becket. British, Canterbury (possibly), ca. 1200–1210. Ivory, 3⅜ x 3⅜ x ½ in. (8.6 x 8.6 x 1.2 cm). Purchase, Rogers Fund, and Schimmel Foundation Inc., Mrs. Maxime L. Hermanos, Lila Acheson Wallace, Nathaniel Spear Jr., Mrs. Katherine S. Rorimer, William Kelly Simpson, Alastair B. Martin, and Anonymous Gifts, 1988 (1988.279)

PADRE MIO SIENO SALUI CHOSTORO PECHATORI
UOLESTI CHIO PATISSI PASSIONE

DOLCIXIMO FIGLIUOLO PECHIMO
TE CHIO TIOIE ABBI MTA DI CHOSTORO

CHANGING IMAGES
OF THE VIRGIN AND
THE CRUCIFIXION

Virgin and Child in Majesty

French, Auvergne, ca. 1175–1200
Walnut with paint, tin relief on a lead white ground, and linen, 31⅜ x 12½ x 11½ in. (79.5 x 31.7 x 29.2 cm)
Gift of J. Pierpont Morgan, 1916 (16.32.194a, b)

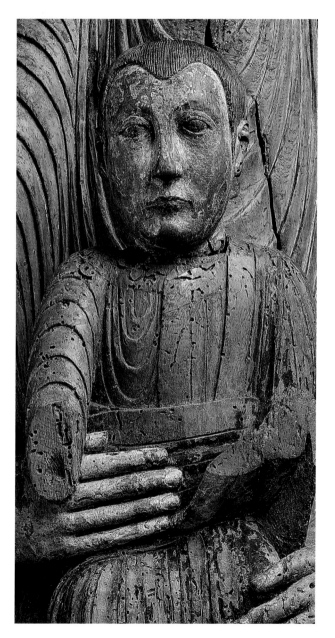

This wooden statue, a masterpiece of Romanesque art, embodies the majesty as well as the humanity of the Virgin and Child. It is one of more than one hundred sculptures from France alone that exemplify a type known as the Sedes Sapientiae, the Throne of Wisdom, that was especially popular in the twelfth century. The seated Virgin is represented symmetrically and frontally, with the Child upon her lap, a characteristic pose for the type. Traces of the original color remain, especially the blue of her robe. The Virgin's expression is severe and reserved, and the Christ Child resembles a little man. His hands are missing, but we know from the many comparable examples that he would have been blessing with one hand and holding a book in the other.

While rhythmic movement is suggested by the repeated arcs of drapery, the figures' stillness and erect posture convey gravitas and authority. Jesus's formal, rigid pose and adult mien announce his power and godliness, while his seat upon his mother's lap asserts his humanity. The sculpture thereby embodies the theology of the incarnation, the belief that Jesus Christ is both God and man. The book he once held made explicit his identification with holy wisdom; as explained at the beginning of the Gospel of John, Christ is the Word, or Logos, of God made flesh. The Virgin, sitting on a simple throne, herself serves as the throne for her child and hence as the throne of Logos, divine wisdom.

The Sedes Sapientiae was the primary formal type of representation of the Virgin at a time when the cult, or veneration, of the Virgin was rapidly developing in western Europe. Throne of Wisdom statues were moved as needed for liturgical functions from one altar of the church to another and were also taken outside and displayed in

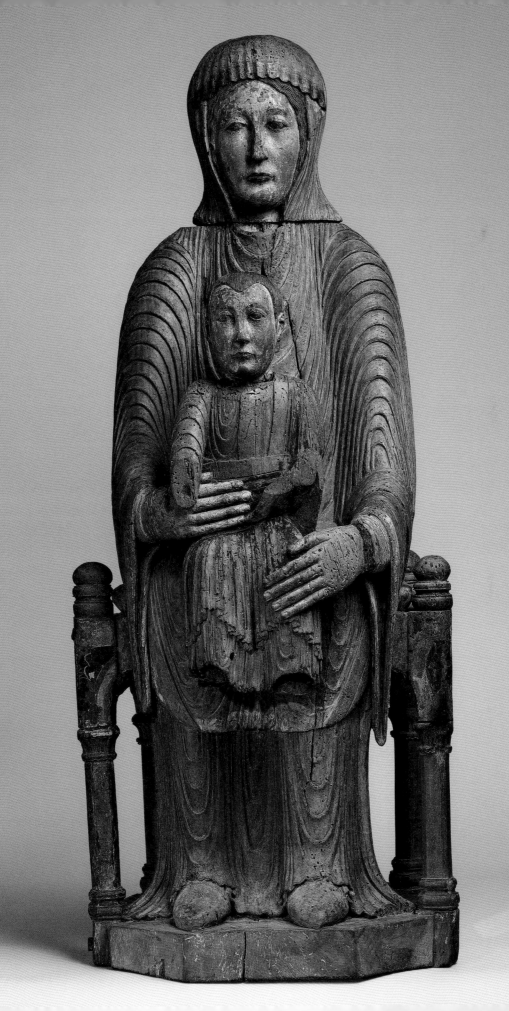

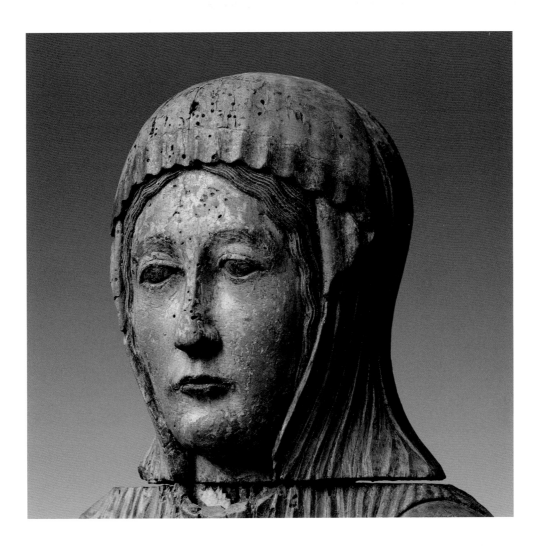

processions. Parade participants in brilliant vestments carried golden crosses or books, candles, and aromatic incense burners. Statues of the Virgin were said to perform miracles and were adorned with jewels and other gifts, or votive offerings, along the processional route. On these journeys through the village, the carvings connected the faithful to the Virgin in heaven.

As wood is more fragile than stone, the survival of so many examples of the Throne of Wisdom today indicates that many more must have been made. Most likely every parish church in twelfth-century France had its own Sedes Sapientiae sculpture. They did not all look alike, and local styles, such as the distinctive drapery folds seen in this one from Auvergne, can be recognized among the extant examples. While this sculpture may appear stiff and unnatural to the modern viewer, its three-dimensionality and polychrome surfaces made the Virgin seem altogether real to the medieval worshiper,

who believed that praying before the sculpture was to pray to the Virgin herself.

Evidence of the statue's perceived potency as the Virgin's proxy is a Romanesque liturgical drama, the *Officium Stellae*, which was performed at the feast of the Epiphany to commemorate the visit of the Magi. Local clerics in silken garments would act out the parts of the three kings, following a star pulled on a string to the church altar, which was adorned for the performance with a curtain. Another costumed performer would proclaim, "Behold, here is the child whom you seek," drawing back the curtain to reveal the Throne of Wisdom statue. Thus the statue assumed the roles of the Virgin and Child in the drama, while all the other parts—the Magi, Herod, angels, and midwives—were played by human actors.

To the medieval viewer, this sculpture was not a work of art. It was an object of great power, the Virgin's agent on earth, capable of working wonders.

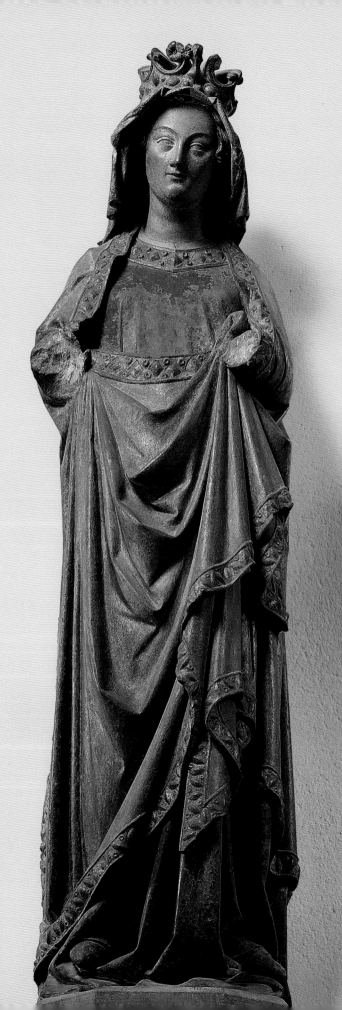

Virgin from Strasbourg Cathedral

Alsace, Strasbourg (present-day France), ca. 1250
Sandstone with original paint and gilding, 58½ x 18½ x 14½ in. (148.6 x 47 x 36.8 cm)
The Cloisters Collection, 1947 (47.101.11)

Carved less than a century after the Virgin and Child in Majesty (entry 22), this lifesize stone sculpture presents a much more human vision of Mary. Her serene face now carries a hint of a smile. The softly molded cheeks, arched eyebrows, and pert chin give her an idealized beauty. Her stance and deeply carved drapery suggest movement. The polychrome paint, much of which survives today, must have made this Virgin even more lifelike and accessible to the medieval worshiper. But if she is more lifelike, she is far from ordinary or humble. This regal figure is clothed in rich garments, with jeweled borders on her dress and robe. Over her veil she wears a huge crown, also carved to appear to be studded with gems. The embodiment of the Queen of Heaven, she was meant to resemble the secular queens of her day, equating their supremacy, heaven mirroring earth. This sculpture dates from a time when the authority of the monarchy was on the rise in France and elsewhere in Europe and royal rulers were at the apex of the feudal system.

The Virgin was addressed as Our Lady (in French, Notre Dame), the title used for the queen and for gentry such as the local lord's wife. The title would have evoked actual women for the medieval worshiper, giving the Virgin an earthly immediacy while also suggesting her sovereign power. The cult of the Virgin that had taken root in the twelfth century continued to grow in the thirteenth, and many new churches and cathedrals were dedicated to Notre Dame. "Salve Regina" (Hail, Queen), an important Marian hymn most likely composed in the eleventh century, had by the thirteenth century become a key component of the liturgy chanted at the end of day. Therefore, the identification of the Virgin as a queen reflects not only the political system but also the liturgical emphasis of the place and period where and when she was made. In contrast with this tradition in the Latin West, the Virgin is not typically shown with a crown in Byzantine art.

This sculpture once stood with a statue of her child beside her on the choir screen of Strasbourg Cathedral, where a transept portal has a representation of the Coronation of the Virgin (see entry 7). The Virgin as Queen of Heaven is a frequent subject in Western art, and in this sandstone sculpture we see one of its most beautiful incarnations.

Bust of the Virgin

Bohemian, Prague, ca. 1390–95
Terracotta with paint, 12⅞ x 8⅞ x 5½ in. (32.5 x 22.4 x 13.8 cm)
The Cloisters Collection, 2005 (2005.393)

Tenderness and sorrow suffuse the face of this beautiful young Virgin made of terracotta, her head tilted as if burdened by her large crown. This bust-length figure was probably originally a full-length standing or enthroned Virgin and Child, a devotional statue intended for the altar of a church. It exemplifies the type known as the Beautiful Madonna, which was disseminated from Prague in the late fourteenth century and widely exported from Bohemia across western Europe.

Like the epithet Notre Dame (Our Lady), Madonna has a simple translation: My Lady. The shift from our to my, from plural to singular, signals a move toward a more personal relationship with the Virgin that occurred in the later Middle Ages, when religious practice increasingly encouraged the worshiper's empathetic response. But it is not only theology that provides a key to understanding this sensitive, youthful Virgin. Literature also yields a clue.

The vernacular poetry of the troubadours glorified secular love. The poet addressed his lady love as "madonna" and pledged his loyalty to her much as a vassal would pledge his service to a lord. As veneration of the Virgin continued to grow through the fourteenth century, some of the language developed in secular love poetry came to be applied to the Virgin. Like the unattainable courtly lady the poet yearned for, the Virgin was an untouchable ideal. In 1289, the French poet Giraut Riquier wrote disdainfully of his former carnal love and used the language of love poetry to describe his rapture for the Virgin.

> Often in the past, I thought I sang of love,
> But I did not know what love is,
> For it was my madness I called by that name.
> Now Love makes me love such a Lady
> That I cannot pay her enough honor,
> Nor fear her nor cherish her as she deserves;
> But I long for her love to hold me so tight
> That I might obtain the boons I hope from her.

It is easy to see how the delicate lady shown here, with her wavy locks, slim nose, and wide brow, could inspire such devotion. The decorative handling of her veil and the finials of her crown, the sensitive modeling of her face, and the touching emotional restraint are all typical of the so-called Beautiful Style from Bohemia. This Virgin perfectly illustrates the ideal described in a medieval love poem by Gautier de Coincy (died 1236) that similarly foreswears secular passions for adoration of the Virgin: "Let us leave off the mad practice of love which drives men mad. . . . Let us love the one who is beautiful and good, sweet and quiet."

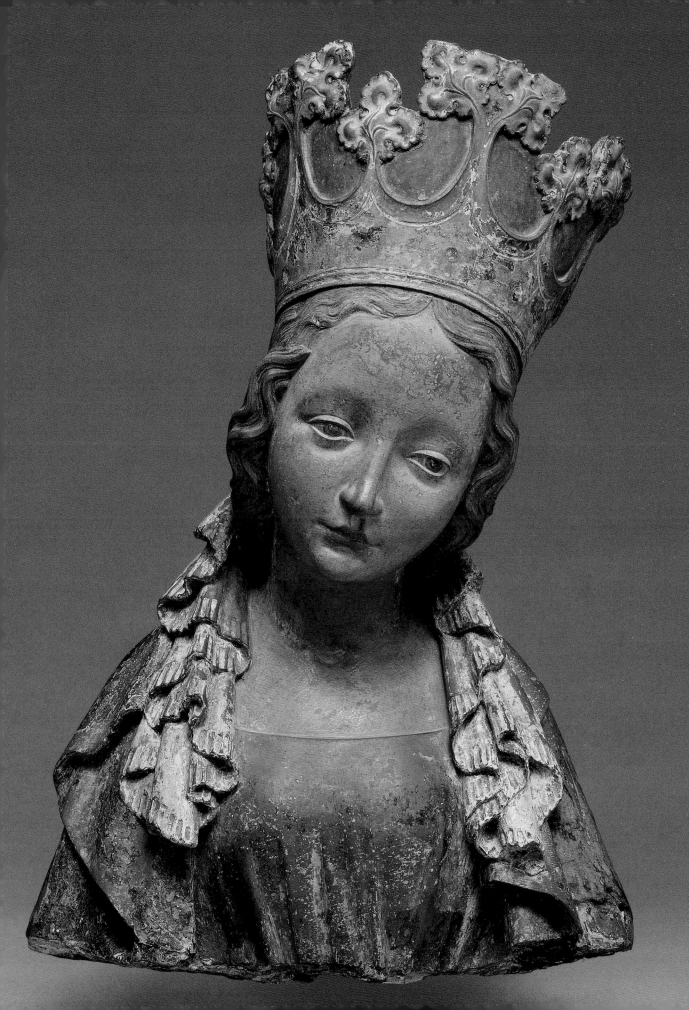

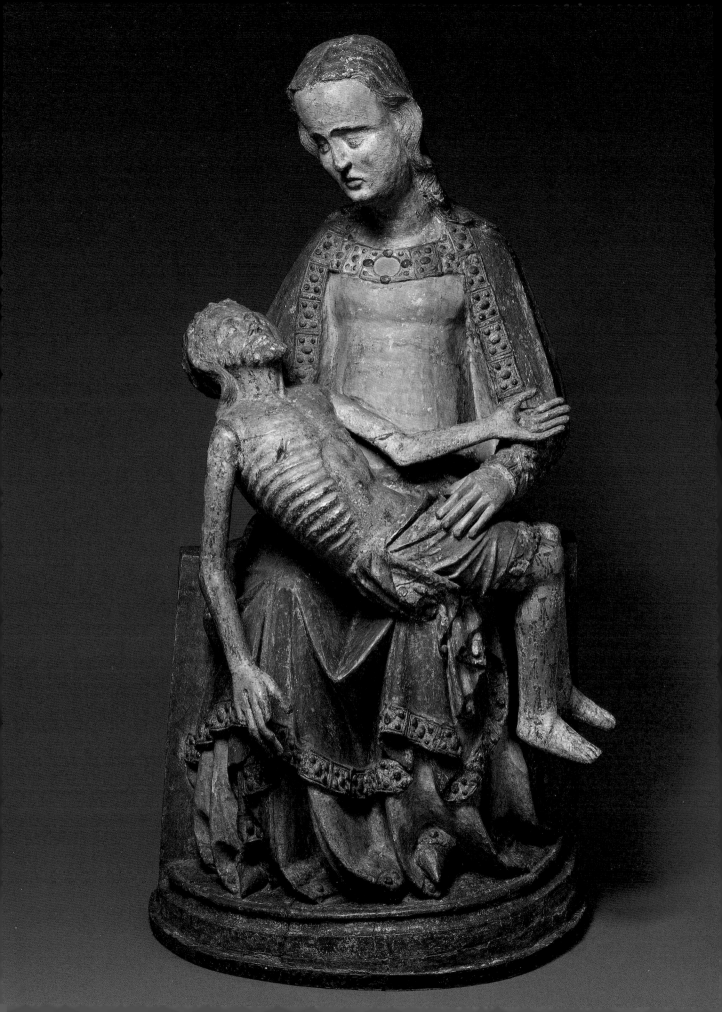

Pietà (Vesperbild)

German, Rhineland, ca. 1375–1400
Poplar with paint and gilding, 52¼ x 27⅜ x 14½ in. (132.7 x 69.5 x 36.8 cm)
Rogers Fund, 1948 (48.85)

Mary appears here in a Pietà ("Pity" in Italian), a depiction of the Virgin cradling her dead son on her lap. This sculpture, like others of its type, is meant to evoke the beholder's compassion: in this example, Jesus's large hands and prominent ribs emphasize his emaciation; the wounds on his chest and hands are frontally displayed and enlarged; and Mary gazes at her crucified son with great sorrow, her eyes downcast, her lips compressed.

The Pietà type originated in Germany, where it is called a Vesperbild (evening image), a reference to the time of day when Jesus was taken down from the cross. The Pietà was an artistic development of the later Middle Ages, evolving from the traditional scene of the Lamentation, in which a group of Jesus's followers, including Mary, gathers around his body after its removal from the cross (see entry 3). This moment after the Crucifixion presents an opportunity for the artist and the viewer to reflect on the very human grief of a mother who has lost her beloved child, with Mary as the Mater Dolorosa (Grieving Mother).

The Pietà became one of the most popular subjects of the later Gothic period (1300–1500), reflecting devotional trends that encouraged worshipers to identify with Christianity's sacred figures. The type gives visual expression to themes also found in contemporary literature and hymns. The "Stabat Mater," an important hymn to Mary that has been set to music by many noted composers, was written late in the thirteenth century and widely in use by the end of the fourteenth. It describes Mary at the foot of the cross and vividly enlists empathy for a mother witnessing the agony of her child.

> Is there one who would not weep,
> Whelmed in miseries so deep,
> Christ's dear Mother to behold?

> Can the human heart refrain
> From partaking in her pain,
> In that Mother's pain untold?

While all Pietàs are meant to arouse sympathy, they differ in style and detail. In this example, the figure of Jesus is much smaller than that of the Virgin, eliciting comparison with images of the Virgin and Child. In so doing, it conveys the contrast between a mother's joy in her baby and her anguish at the death of her grown son.

The later Middle Ages saw an increase in art's emotional and expressive range, reflecting extremes of joy and sadness in response to the challenges of the times. In the mid-fourteenth century, between one- and two-thirds of the population of Europe died from the bubonic plague. Death was ubiquitous and mourning was a constant in people's lives; the psychological impact was enormous. The emotionally charged Pietà reflected that experience and channeled it into expressions of piety and pity, making the subject especially successful in the century of the Black Death.

Attributed to Claus de Werve (Netherlandish, active in France ca. 1380–1439)

Virgin and Child

French, Burgundy, Poligny, ca. 1415–17
Limestone with paint and gilding, 53⅜ x 41⅛ x 27 in. (135.5 x 104.5 x 68.6 cm)
Rogers Fund, 1933 (33.23)

The joys as well as the sorrows of the Virgin were celebrated in the later Middle Ages. This work, carved in limestone and softened in effect by color, convincingly displays an image of loving motherhood. Mary engulfs her son in a tender embrace within the shelter of her voluminous robe. Jesus is a chubby baby, no longer the solemn miniature man of earlier works (see entry 22). Her left hand presses gently into his side, holding him securely. The long wavy hair cascading down her shoulders contrasts with her child's short curly locks, demonstrating the artist's ability to carve varying textures. While they gaze at each other, the focus of their exchange is the large book they hold, supported by Mary's lap and propped up by one of her son's feet (as can be seen on page 134). Its realistically represented pages and binding strap are consistent with the scale of an illuminated manuscript Bible. Mary's fingers clearly mark a group of pages, tilting them toward Jesus, who points to a passage as he looks at her expectantly, his lips slightly parted as if in speech. They seem to be discussing or noting a particular Bible text, such as the one inscribed on the right side of the bench on which Mary sits, which alludes to the belief that Christ is eternal. At the same time, the intimate representation of Jesus as an endearing baby in his mother's arms emphasizes his human nature. As such, this sympathetic portrayal communicates the doctrine of Christ's dual nature as God and man. The book and the overall pose further denote the Sedes Sapientiae, the Virgin as the Throne of Wisdom (entry 22).

Although medieval worshipers may have grasped those profound theological messages, they could also approach this wonderful work of art with empathy alone, a key to the spirituality of the period. When this image was carved, the devout were encouraged to imagine the feelings Mary and Jesus experienced during the major events of their lives. One of the principal texts to promulgate this practice is *Meditationes vitae Christi* (*Meditations on the Life of Christ*). It was written in the fourteenth century by a Franciscan monk as instruction to a nun in the sister monastic order of Poor Clares. The text advises the reader to meditate and envisage herself in the story, for example, visiting Jesus in his crib and kissing him. This late medieval guide to devotion was so popular that more than two hundred manuscript copies still exist.

That the *Meditationes* was written for a Poor Clare is especially relevant to this sculpture, as it was made for the Franciscan convent of Poor Clares in Poligny, France. Claus de Werve, the probable sculptor of this monumental work, was a court artist to John the Fearless, duke of Burgundy (1371–1419). John and his wife, Margaret of Bavaria, founded the convent at Poligny and most likely commissioned this work for that cloister. In the fifteenth century, the nuns there would have regarded it as an aid to their own meditation on the life of Jesus and the Virgin, in which they could read both spiritual meaning and human tenderness.

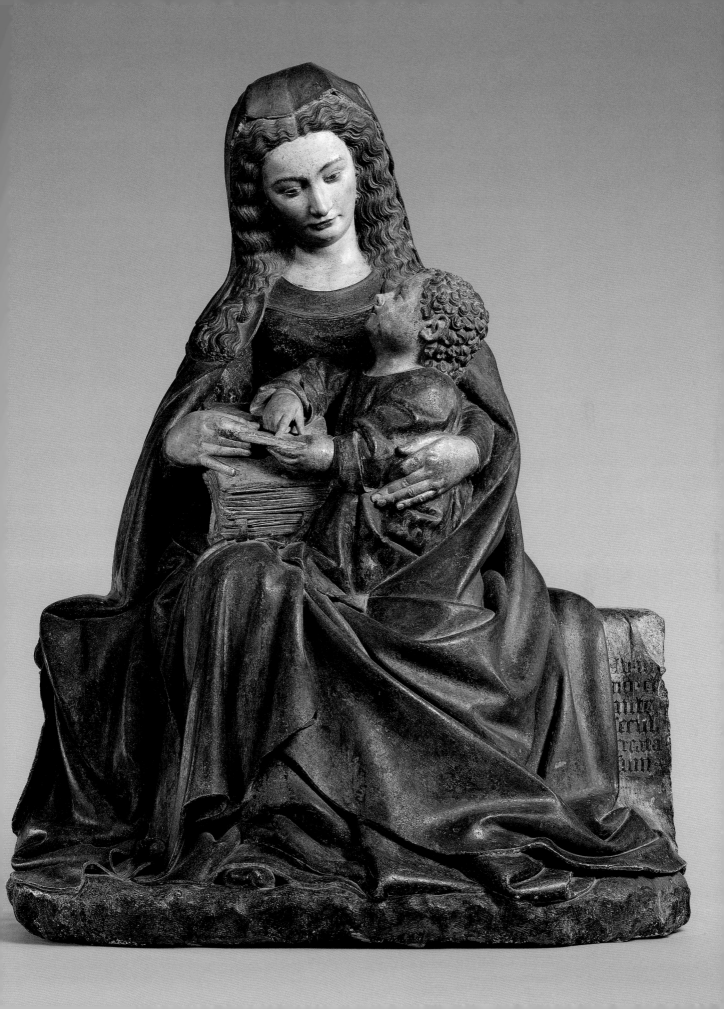

Portable Icon with the Virgin Eleousa

Byzantine, probably Constantinople, early 14th century
Mosaic set in wax on wood panel, with gold, multicolored stones, and gilded copper,
4½ x 3⅜ x ½ in. (11.2 x 8.6 x 1.3 cm)
Gift of John C. Weber, in honor of Philippe de Montebello, 2008 (2008.352)

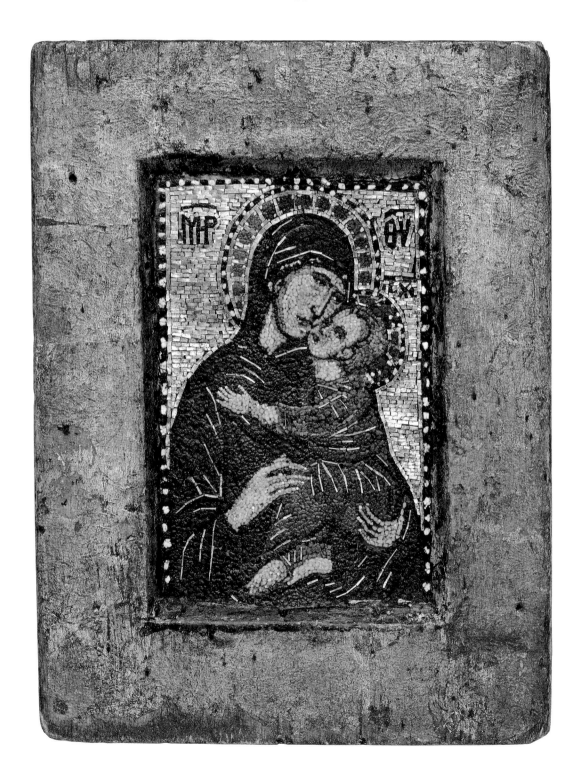

Figure 21. Chalice (detail). Byzantine, Syria, Attarouthi, late 6th–early 7th century. Silver and gilded silver, overall H. 9⅝ (24.3 cm), Diam. 6⅝ in. (16.8 cm). Purchase, Rogers Fund and Henry J. and Drue E. Heinz Foundation, Norbert Schimmel and Lila Acheson Wallace Gifts, 1986 (1986.3.1)

In the art of the Byzantine Empire, the Virgin Mary is the most common subject of icons, which are considered in Orthodox worship to be representatives on earth of their subject in heaven (see entry 6). To ensure the efficacy of the image as a conduit to the Virgin herself, the artist was motivated to respect and continue a sacred tradition rather than to create something new. Therefore, images of the Virgin in Byzantine art most often accord with one of several types, each of which has its own history, name, and associations. Through gaze, gesture, and expression, they communicate powerfully with the worshiper.

This tiny icon (greatly enlarged here) exemplifies one widespread type of Mary in the Orthodox tradition, the Eleousa, the Virgin of Tenderness or Virgin of Compassion. The Virgin holds her baby in a gentle and intimate embrace, her cheek against his, in an affectionate and affecting image of warm and nurturing motherhood. The mosaic is made of individual stones and bits of gold no larger than the head of a pin.

The Virgin's central importance in the Eastern Church is reflected in her title Theotokos (One Who Gives Birth to God), paraphrased and used in inscriptions as Meter Theou (Mother of God), abbreviated on this and many other icons as MP ΘY. This epithet emphasizes her role as his mother, a subject of debate in the early church, when some questioned how a human could contain God. The Eleousa's tenderness meshed perfectly with the Latin Church's focus on empathy in the late medieval period (see entries 25, 26, 33), and this Byzantine type was profoundly influential in Western art, both in Italy and in northern Europe (see fig. 5), into the Renaissance.

The Eleousa is only one of the many Byzantine types for the Virgin; two others of a more ancient lineage are also shown here. One is on a large and precious gilded silver chalice dating to the late sixth or early seventh century (fig. 21). The Virgin, seated beneath one of the arches that circle the cup, holds up both arms in prayer, a pose called orans (from the Latin for "praying"). Orant figures are seen frequently in the earliest Christian art, as well as in earlier pagan and Jewish art. Both ordinary people and biblical figures were represented in the prayerful pose in those early periods, but in later Byzantine art the pose was typically reserved for the Virgin.

Another important and ancient type is the Hodegetria (She Who Shows the Way), seen here in an ivory of the tenth or eleventh century (fig. 22) but known in examples from as early as the sixth century. This carving (excised from a relief panel) shows the Virgin in the characteristic Hodegetria pose: standing, holding the Child in her left arm, and gesturing toward him with her right hand, indicating that he is the path to salvation.

Figure 22. Icon with the Virgin and Child. Byzantine, probably Constantinople, mid-10th–mid-11th century. Ivory, 9¼ x 2¾ x ½ in. (23.4 x 7 x 1.3 cm). Gift of J. Pierpont Morgan, 1917 (17.190.103)

Attributed to Lorenzo Monaco (Piero di Giovanni) (Italian, ca. 1370–1425)

The Intercession of Christ and the Virgin

Italian, Tuscany, Florence, before 1402
Tempera on canvas, 94¼ x 60¼ x 1 in. (239.4 x 153 x 2.5 cm)
The Cloisters Collection, 1953 (53.37)

This fascinating painting gives the doctrine of intercession beautiful and instructive form. It is a work of art that is made to be read, but more like a prayer than a narrative. The sequence begins at the bottom with the small-scale figures who hold their hands in a gesture of penitential humility. They are clothed in the garments of the period and include women and men, a nun and laypeople. While they gaze expectantly toward the figure of Christ, they are under the protective care of the Virgin, who presents them to him with her right hand. The contrasting scale of human and sacred figures, signifying their relative importance, has a long history in art, dating to at least the third millennium B.C. With her left hand, Mary holds out her veiled breast to her son. Beautiful lettering in Italian,

horizontally linking her face to his, expresses her request of him: "Dearest son, because of the milk that I gave you, have mercy on them." Christ's gesture toward her indicates his affirmation. Wounds from his crucifixion are visible on the back and palm of his hands, one of which gestures to the gash in his side. His words rise at an angle toward the figure above; translated from Italian, they say, "My Father, let those be saved for whom you wished me to suffer the Passion."

This sequence, from the petitioning humans, to Mary, to Christ, and, finally, to God the Father, can also be read in reverse: God sends down his mercy in the form of the dove of the Holy Spirit to Christ, who passes on the absolution with his gesture to Mary, as she proffers it to the

penitents. This painting thus eloquently presents the Virgin's power to intercede for the faithful. In scenes of the Last Judgment (see entry 7), the Virgin often appears as advocate for souls rising from their graves.

Her role as intercessor was cited in a twelfth-century text that became more widely known when it was included in a popular fourteenth-century anthology, the *Speculum humanae salvationis*: "Man now has sure access to God, with the Son as his advocate before the Father, and the Mother as advocate before her son. Christ, uncovering his side, shows its wound to his Father; Mary shows Christ her breast; nor is there any way she can be refused."

As this painting demonstrates so graphically, the Virgin's supreme power as intercessor derives from the incarnation: God was able to become man only because he had a human mother, and the essence and symbol of that physical motherhood is the breast Mary offers. This idea is also expressed in art by the image of the Virgin nursing her baby (see entry 1 and fig. 23), an important type that occurs in Byzantine as well as Western art from earliest Christian times to the present day. Mary's authority as intercessor also derives from her special status in the celestial firmament, where she was crowned Queen of Heaven (see entries 7, 23). The penitent could therefore regard her as both a formidable and eternal advocate and an accessible, nurturing human mother. The lyrical and sympathetic portrayals of the heavenly figures here enhance the expressive power of this large devotional painting, which once hung in Florence's cathedral.

Figure 23. The Limbourg Brothers. Virgin and Child Enthroned (detail of fol. 157v), The Belles Heures of Jean de France, Duc de Berry (see entry 19)

PADRE MIO SIENO SALUI CHOSTORO PGQUALUNQTA
VOLESTI CHIO PATISSI PASSIONE

FIGLIUOLO MIO DOLCISSIMO PERLATTE
CHIO DIO TIDIE ABBI MIA DI CHOSTORO

Workshop of Robert Campin (Netherlandish, ca. 1375–1444)

Annunciation Triptych (Merode Altarpiece)

South Netherlandish, Tournai (present-day Belgium), ca. 1427–32
Oil on oak, central panel 25¼ x 24⅞ in. (64.1 x 63.2 cm), each wing 25⅜ x 10¾ in. (64.5 x 27.3 cm)
The Cloisters Collection, 1956 (56.70a–c)

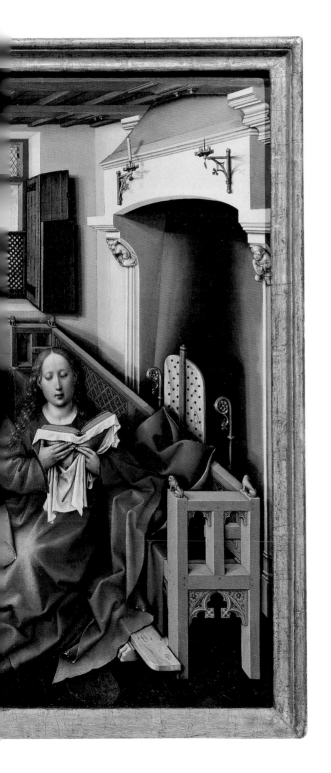

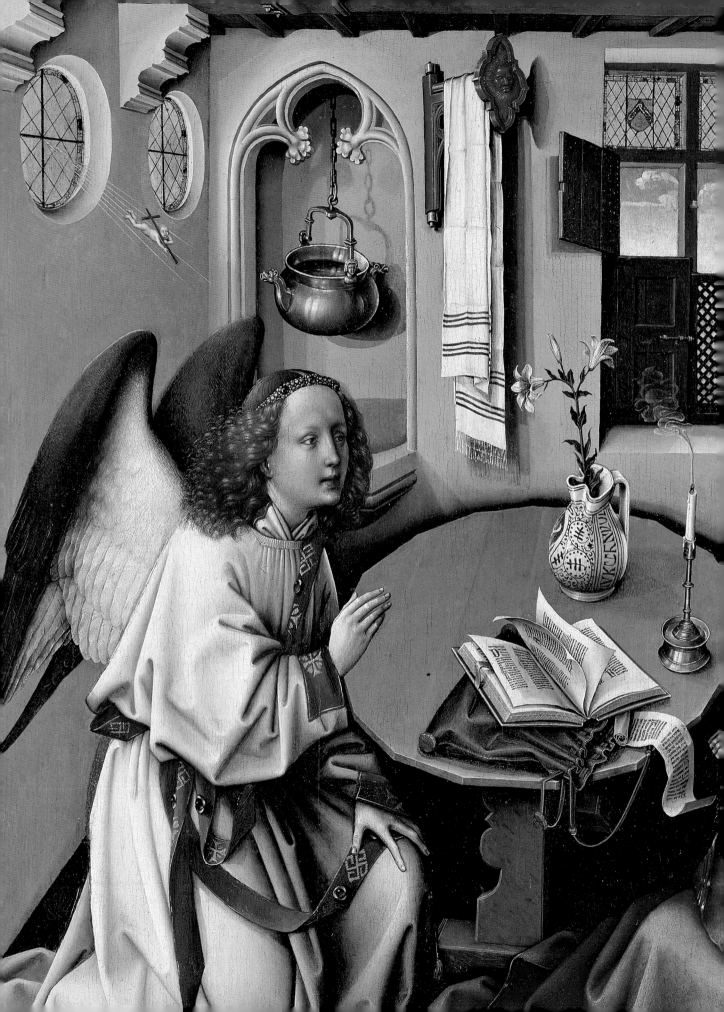

In this painting, one of the chief glories of The Cloisters collection, the Virgin Mary appears as a humble maiden in a domestic interior that would have seemed familiar to any burgher of fifteenth-century Flanders. The furniture, beamed ceiling, shuttered leaded windows, and other architectural features are all typical of Netherlandish homes. Adding to the verisimilitude are the brass pot hanging in a niche beside a white towel with blue stripes, the pitcher holding flowers and the brass candlestick beside it on the table, and the long wooden bench against which the Virgin leans.

By incorporating such contemporary details, the artist linked the sacred past to his present. The central panel depicts the Annunciation, when the Archangel Gabriel brings news of the incarnation to Mary (see entry 1), in such a way that the fifteenth-century viewer of this altarpiece could imagine the event taking place in his own home. The details provide another layer of meaning as theological symbols. The pot is a laver (washing basin) and, with the white cloth, refers both to the Virgin's purity and to one of her epithets, Well of Living Waters. The white lily is another emblem of her purity. The flame of the candle on the table has just gone out in a puff of smoke. The key to understanding its symbolism is the tiny figure of a baby holding a cross who flies on golden rays through one of the round windows in the upper left corner. This is the Child, understood as divine light, miraculously entering Mary's womb in the incarnation while her virginity remains intact, just as he passed through the leaded glass window without breaking it. As the divine light enters, the earthly light of the candle is extinguished. (The more typical Annunciation iconography includes the dove of the Holy Spirit [see fig. 6] instead of the minuscule Child.)

The book Mary is reading and the open book on the table establish her wisdom, while her humility is conveyed by her low seated position on the footrest of a bench. The details of the bench are meaningful too. The Old Testament records that the throne of the wise king Solomon was embellished with lions, as is the bench, indicating to the medieval viewer that it represents the Throne of Wisdom, which was also called the Throne of Solomon. This different depiction of a centuries-old concept and epithet for the Virgin (see entries 22, 26) is yet another indication of how representations of Mary changed over the course of the Middle Ages. As the spiritual lessons taught through her example evolved, the way she was presented changed accordingly: the severe and hieratic figure became a tender and emotional mother and then, as seen here, a modest young woman from the town.

The wings of this brilliant altarpiece add to both its symbolic meaning and visual appeal. The right panel shows Joseph, said to have been a carpenter, working in his shop. The wooden mousetraps on his workbench and the windowsill allude to a sermon by the influential early Christian theologian Saint Augustine: "The cross of the Lord was the devil's mousetrap." In the left panel, two figures kneel before a door that appears to open onto the central panel; they are the donors of the altarpiece and witnesses to the Annunciation. Behind them is a rosebush in a gated garden, two symbols of Mary's intact virginity.

Beyond the triptych's theological symbolism, it offers visual delight in its crystalline details. All three sections have passages that reward close and long observation, whether the flowers in the foreground of the left panel, the gradations of color in Gabriel's wings, or the miraculously detailed and believable Flemish cityscape viewed through Joseph's window, where tiny figures, singly and in pairs, walk the cobbled streets.

30

True Cross Reliquary

Byzantine, Constantinople (?), ca. 800
Gilded silver, gold, cloisonné enamel, and niello, 1⅛ x 4⅛ x 2⅞ in. (2.7 x 10.3 x 7.1 cm)
Gift of J. Pierpont Morgan, 1917 (17.190.715a, b)

 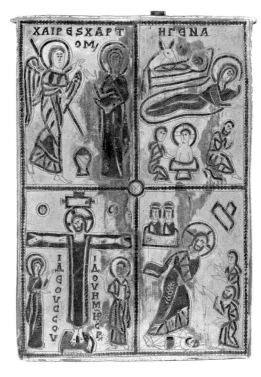

This is the earliest representation of the Crucifixion in the Metropolitan Museum's collection, and it preserves an iconographic type that is hundreds of years older. It appears on a compact gilded silver box, about the size of a pack of playing cards, with a sliding lid. The lively enamel colors—sky blue, yellow, and brown—stand out against an emerald ground and attract the eye. Beaded gold defines panels that surround the large scene in the center of the lid. Here, Jesus appears to stand against the cross, as stiff and straight as the shaft itself, rather than to hang from it. His eyes are open, and his straight arms extend to the sides in a T, his palms facing the viewer. He wears a colobium, a long, sleeveless, ancient Roman garment. His head is encircled by a cross nimbus (a halo inscribed with a cross),

with the sun and moon just above. All those features are characteristic of Crucifixion scenes from the eastern Mediterranean in the sixth century. In this iconographic type known as Christ Triumphant, Jesus, erect and open-eyed, appears as if alive. Death has no victory over him. The sun and moon above allude to his eternal dominion over the heavens and earth.

Beside Jesus stand the Virgin and Saint John, each identified by a vertical inscription in Greek, each holding one hand to his or her face in a formalized gesture of mourning. This central scene is framed by busts of saints, and additional saints appear around the sides of the box. Another representation of the Crucifixion with the same elements is depicted in niello (dark mineral inlay) on the

underside of the lid, together with three other familiar scenes: the Annunciation, the Nativity, and the Anastasis (see entries 1, 6).

Inside this colorful little box is a cross-shaped compartment that once contained a relic of the True Cross, a piece of wood believed to have been part of the cross on which Jesus was crucified. Helena, the mother of Constantine the Great, was said to have found the True Cross in the fourth century, and fragments of wood said to have been part of it were highly valued objects of veneration. Byzantine emperors sometimes gave them as diplomatic gifts, and such fragments were the chief treasures of rulers and popes throughout the Middle Ages, both in the Latin West and Byzantine East. The smallest splinter of wood was believed to have the power of the whole, as was the case for all relics, and the ability to transmit prayers directly to Christ.

This reliquary, skillfully made with precious materials to honor its sacred contents, the iconography of Christ Triumphant, and the relic itself all served to connect the devout to God and his promise of salvation.

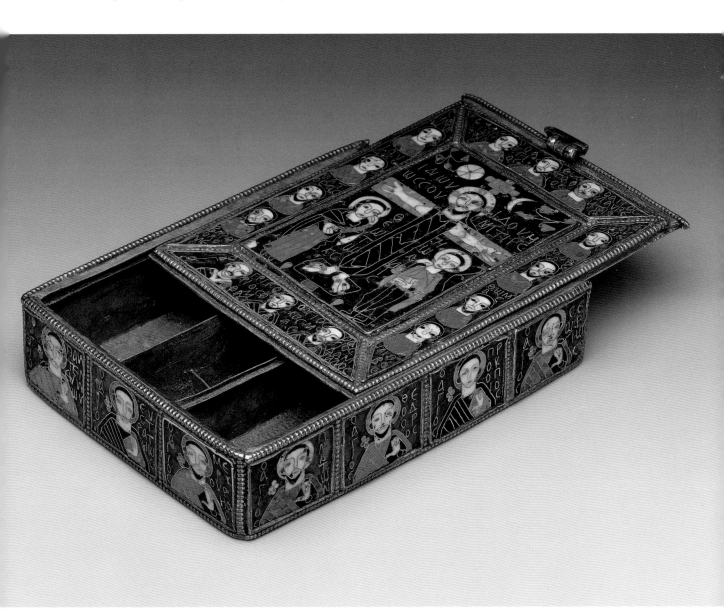

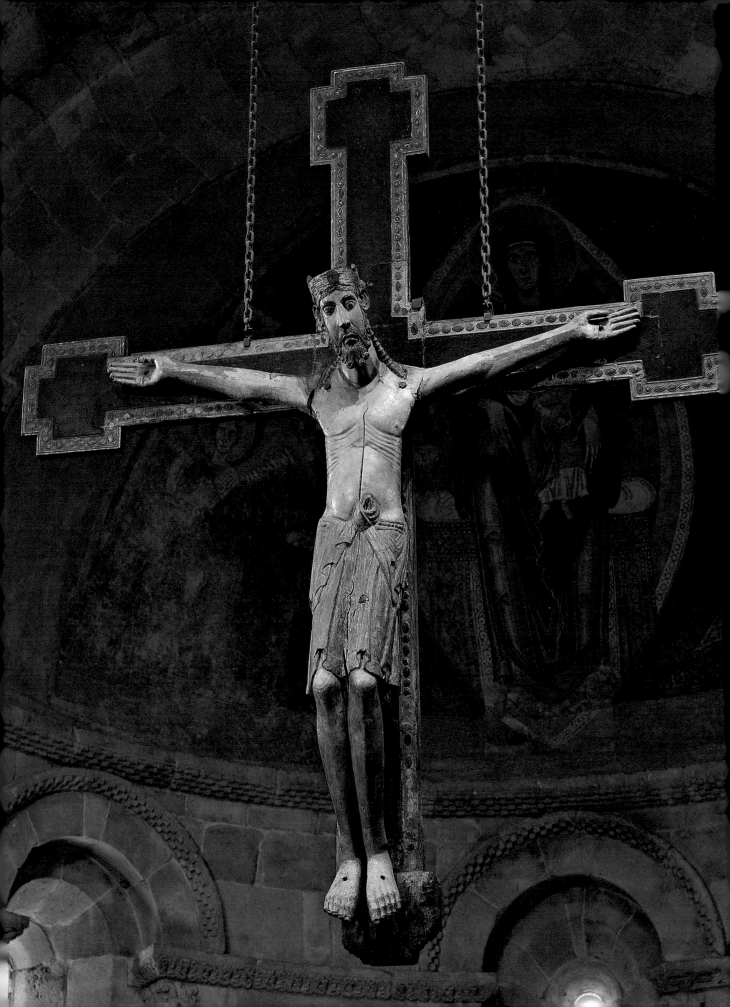

Monumental Crucifix

Spanish, Castile-León, ca. 1150–1200
White oak with paint, gold leaf, and tin leaf (corpus); softwood with paint and
tin leaf (cross), 8 ft. 6½ in. x 6 ft. 9¾ in. x 1 ft. 3¾ in. (2.6 x 2.1 x 0.4 m)
Samuel D. Lee Fund, 1935 (35.36a, b)

With this imposing object, suspended from the apex of the great Romanesque apse at The Met Cloisters, we confront a truly monumental portrayal of the Crucifixion. The crucifix sculpted in the round was a western European phenomenon, as the Byzantine world had condemned three-dimensional imagery at the Second Council of Nicaea in 787 (see Introduction).

In this important Spanish work from the Romanesque period (eleventh through twelfth century), the figure is more than six and a half feet tall. Much original paint survives, especially on Jesus's face and beard. His long hair falls in braided locks over his shoulders, while his beard is neatly and symmetrically curled. His thin ribs also are symmetrical, as is his loincloth, which is tied in front in a prominent knot. Jesus's body does not droop, his head is erect, his eyes are open, and his expression is calm, all characteristics in the tradition of representing Christ triumphant over death. The large gilded crown on his head signifies his dominion over all. It was once studded with jewels of painted wood; now, only those toward the back remain. Simulated jewels also decorate the border of the cross. These signs of wealth emphasize Christ's majesty. Although his eyes are open, this Jesus differs from the earliest type, exemplified by the True Cross reliquary (entry 30). His body and limbs are less rigidly cross-shaped, with bent knees and angled arms. Instead of the colobium, he wears a loincloth, which exposes more of his body. While his near-nakedness and the articulation of his chest and ribs bring a measure of the human to this representation, its paramount theme is still Christ Triumphant.

In the High Middle Ages in the Latin West, a monumental crucifix like this one would have hung high above the altar of a cathedral, visible to the whole congregation. This object must originally have occupied a similar position of dominance and honor, suspended away from any walls and therefore seen from all sides; the reverse was intended to be viewed, as can be surmised from the surviving but much-faded painting, including traces of Evangelist symbols (entry 16), the Lamb of God (see entry 14 and fig. 15), and foliate ornamentation.

The open-eyed, crowned, and thus triumphant Christ is a type that endured in Spain longer than in other areas of Europe, but here the softness of his abdomen and the traces of painted blood at the sites of his wounds both attest to his vulnerable humanity and anticipate the future treatment of the Crucifixion. The image of a regal king victorious in death would increasingly give way to representations of Jesus's pathos and suffering.

Icon with the Crucifixion

Byzantine, probably Constantinople, mid-10th century
Ivory, 6 x 3½ x ⅜ in. (15.1 x 8.9 x 0.8 cm)
Gift of J. Pierpont Morgan, 1917 (17.190.44)

In this small, exquisite icon suitable for private devotion, a delicate openwork canopy skillfully carved of ivory shelters a poignant Crucifixion scene. Christ's arms are no longer fully extended, and his body is no longer erect, as seen in the two prior examples (entries 30, 31). The Virgin and John flank him, as in the True Cross reliquary (entry 30), but they now more openly express their grief. John brings one hand to his cheek, while the Virgin gestures mournfully toward the body of her son with one hand and draws her mantle to her breast with the other. Both wear beautifully detailed drapery that recalls classical prototypes. Three soldiers seated below the footrest of the cross draw lots to divide Jesus's garments among themselves. Most of this scene's iconography is standard; it recurs not only in Byzantine art but also in the art of the medieval West. But the image of the bearded man impaled at the base of the cross is unique. This reclining, seminude figure grasps the cross as its base pierces his torso like a sword, with drops of blood issuing forth. The inscription between this figure and that of John translates: "The cross implanted in the stomach of Hades." In Greek mythology Hades is the ruler of the underworld and hence a personification of death. The cross impaling Hades thus signifies Christ's triumph over death and the cross as a weapon against hell.

In earlier Crucifixion scenes, the triumph over death was expressed by Jesus's open eyes and erect stance. In contrast, by the tenth century Byzantine Crucifixion icons like this one depict Jesus's body hanging limply from the cross. His head falls forward and toward his shoulder. His enlarged hands appeal for our sympathy. He wears a loincloth that conveys vulnerability by barely covering his nakedness, instead of a long colobium that shields his body. During the Iconoclastic Controversy of the eighth and ninth centuries, a key and ultimately winning argument in favor of figural representation was that

God had become man, and images of humans were permissible. To avoid making images of Jesus would be to deny his humanness and hence the incarnation. Accordingly, in the posticonoclastic Eastern Church, art emphasized Jesus's humanity and mortality, presenting his body as shown here, near-naked and in death, to justify the creation and veneration of images. To preserve the sense of triumph over death while making manifest the suffering on the cross, the maker of this icon added the unique iconography of the disemboweled Hades beneath the bowed figure of Jesus, combining complex theology with a moving image meant to elicit empathy.

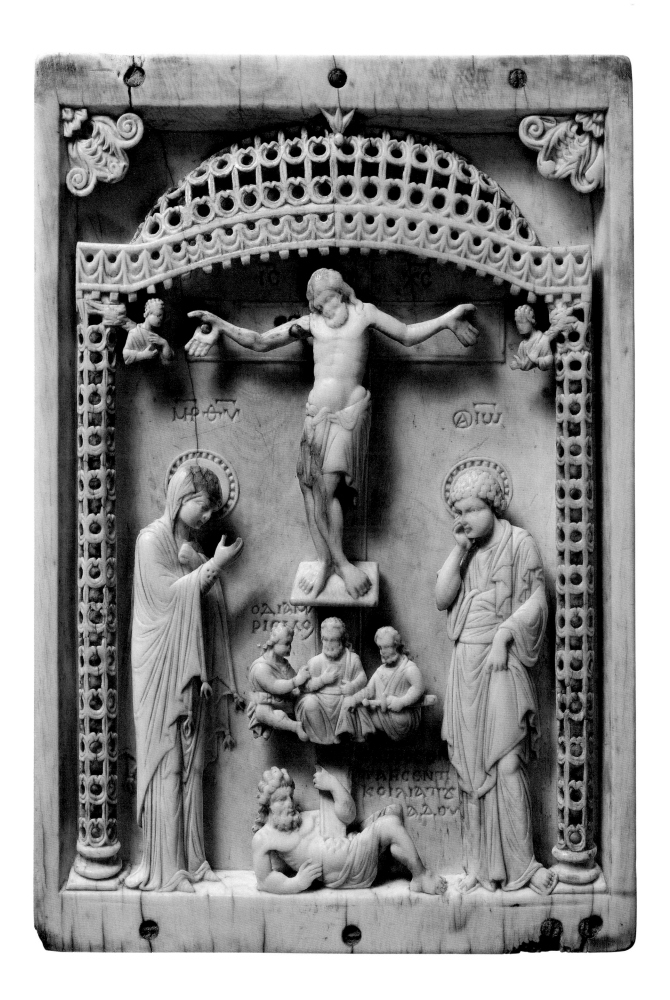

Master of the Codex of Saint George (Italian, active Florence ca. 1315–35)

The Crucifixion

Italian, made in Avignon, France, ca. 1330–35
Tempera on wood, gold ground, 18 x 11¾ in. (45.7 x 29.8 cm)
The Cloisters Collection, 1961 (61.200.1)

Just as the image of the Virgin evolved during the Middle Ages from an emphasis on majesty and power to a focus on tenderness and maternal love, representations of the Crucifixion shifted from triumph to pathos. Reflecting changing theological and societal values, art brought the humanity of both Mary and Jesus to the fore over time.

In this beautiful yet disquieting Crucifixion painted by an Italian master, suffering is explicit. Blood pours from Jesus's wounds, trickling from his hands down the length of his arms, spurting from his chest, running from his feet toward the base of the cross, and pooling onto the rock and skull beneath. His entire body is exposed; a translucent loincloth only veils his thighs. He truly hangs from the cross, his body slumped and bowed away from it. Jesus's face is dignified, expressing patience in his misery. In contrast, the faces of his followers register an outpouring of grief. The youngest apostle, John, tilts his head away, as if he cannot bear to look at the pathetic body of his lord. The Virgin covers her mouth with a veiled hand, as if stifling a sob.

Both the sacred art and the spiritual literature of the fourteenth century emphasized emotion, reinforcing one another in encouraging the worshiper to identify with the suffering of Jesus and the Virgin at the Crucifixion. The *Meditationes vitae Christi*, cited earlier (see entry 26), imagined in detail each hour of the day of the Crucifixion. Regarding the sixth hour, it reads: "Behold the Lord Jesus is crucified and extended on the cross. . . . On all sides, rivers of His most sacred blood flow from His terrible wounds." Such texts, as well as sermons and other religious writing that described and interpreted works of sacred art, guided believers in their empathetic viewing of the Crucifixion. The medieval Christian's understanding of such images was shaped by what his priest told him to see.

The figures of Christ, the Virgin, and John carry the central emotional charge in this panel painting, but the story is elaborated with additional figures, witnesses to and participants in the scene. Holy women accompany the Virgin; Mary Magdalen stands behind her wearing garments of electric orange and pink. Behind the holy women and also behind John are soldiers in blue helmets. The one on the right extends his arm toward the figure of Christ. He is the centurion Longinus, who recognized the divinity of Christ on the cross and became the first of the Romans to convert. Alone among the soldiers, he has a halo in acknowledgment of his new faith.

In this painting, which was likely one panel of a folding polyptych, wrenching emotional pain contrasts starkly with the lyrical beauty of the treatment. Brilliant colors in surprising combinations play off the glittering gold background. Drapery is shown in graceful sweeps and sinuous lines. Faces are softly modeled, and their glances direct the viewer's gaze through the composition. Each halo bears ornamental patterns created by punches that enhance the gilding's reflective qualities. The loveliness allures even as the bloody scene repels, calling us to empathize with the suffering placed before our eyes.

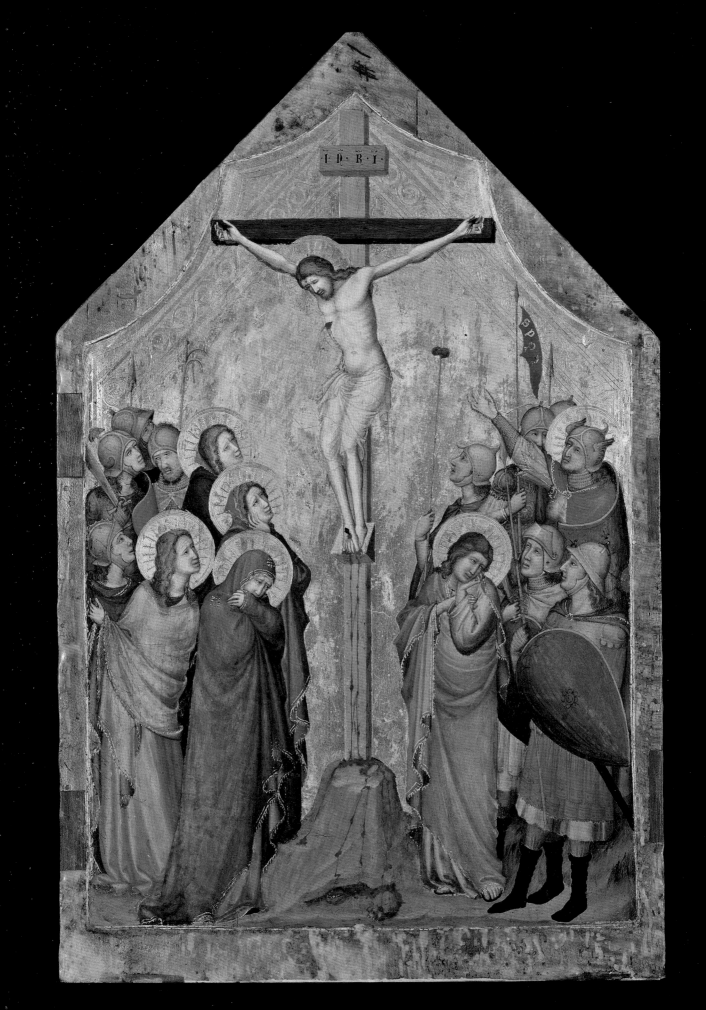

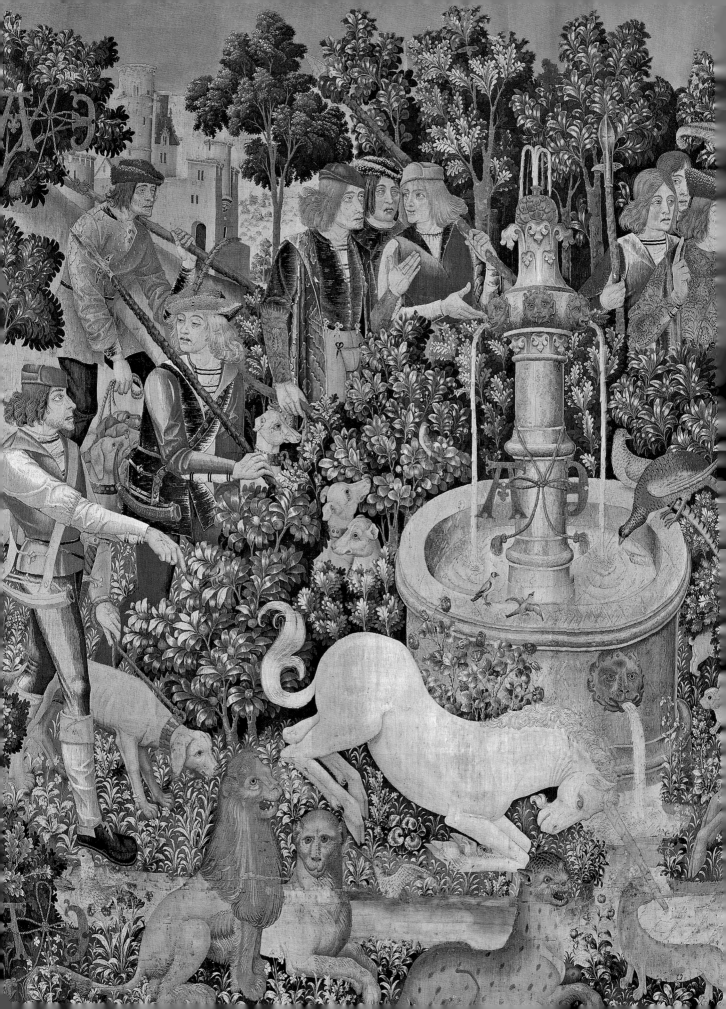

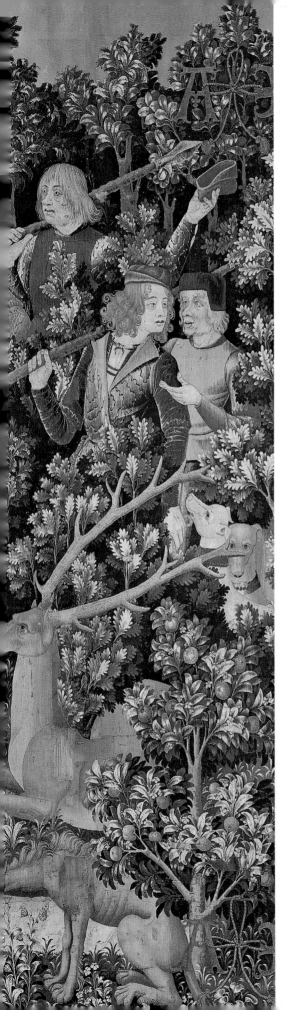

SECULAR
THEMES

Casket with Warriors and Dancers

Byzantine, Constantinople, 11th century
Ivory and bone with gilded copper mounts, 8 x 11⅜ x 7½ in. (20.3 x 28.9 x 19.1 cm)
Gift of J. Pierpont Morgan, 1917 (17.190.239)

The comical seminaked figures cavorting across this finely carved casket illustrate one of the secular themes that can be found in the art of the Middle Ages. Although religious subjects predominate in medieval art, these little warriors with their spears and shields and dancers with their tambourines have nothing to do with Christianity, instead representing classical motifs. All the figures and ornaments on this bone and ivory box have an ancient pedigree. The gesture of each cherub on the gable of the lid, dancing and waving an arc of drapery over his head, is a trope that derives from Hellenistic and Roman carvings. The fellows armed with swords and shields strike poses first sculpted in ancient Greece. On the top of the lid, two more cherubs, or erotes, lead a female panther, a detail that aligns them even more closely with the pagan past: the panther was associated with Dionysus, the Greek god of wine. Also classical in origin is the use of framing to demarcate areas of figural representations, like the bands of rosettes around the dancers and warriors. The scrolling vine that frames some of the dancing figures likewise originates in antique prototypes and has a long history in medieval and Islamic art.

The owner of this highly decorative casket would have sensed no conflict between the pagan imagery and his or her Christian faith. The citizens of the Byzantine Empire called themselves Romans and considered their realm the true heir to the ancient Roman Empire. Local monuments from the Greek and Roman past had survived, serving as models for the many classical motifs that persisted in Byzantine art. The presence of a river god on the great silver plate showing the battle of David and Goliath (entry 8) is another example of pagan imagery surviving intact in Byzantine art. Classical literature and philosophy had survived as well. The educated classes of the Byzantine Empire studied Homer and other ancient Greek authors. An epigram directed to Christ by the eleventh-century scholar John Mauropus demonstrates both the high esteem for classical authors and the integration of the Christian and the classical in the Byzantine world view.

If perchance you wish to exempt certain pagans from
 punishment, my Christ,
May you spare for my sake Plato and Plutarch,
For both were very close to your laws in both teaching
 and way of life.
Even if they were unaware that you as God reign over all,
In this matter only your charity is needed,
Through which you are willing to save all men while
 asking nothing in return.

Images of classical figures are particularly suitable to the secular arts prized by members of courtly society educated in such literature. This casket, which may have held valuables or been a gift to a visiting dignitary, reflects a taste for display as well as respect for artistic virtuosity.

While the people of the Byzantine Empire celebrated its continuity with Greco-Roman history, preserving

its memory, art of the Latin West typically translated the ancient world into contemporary imagery. For example, the Netherlandish Heroes tapestries (entry 10) originally included three ancient worthies—Hector, Alexander the Great, and Julius Caesar—bearing medieval swords and shields and framed by Gothic architecture. Nothing in their dress and accessories acknowledges the centuries that separated Hector from Caesar, or the millennium between Caesar and the tapestry makers. Notwithstanding their different approaches to depicting themes and figures from the ancient world, the Orthodox East and Latin West both prized classical imagery, which has an important and recurring role in medieval art.

Casket with Scenes from Romances

French, Paris, ca. 1310–30
Elephant ivory, 4⅜ x 10 x 6¼ in. (10.9 x 25.3 x 15.9 cm)
Casket: Gift of J. Pierpont Morgan, 1917 (17.190.173a, b);
front panel: The Cloisters Collection, 1988 (1988.16)

This ivory box is a luxury item, made to hold jewelry or other valuables. Every side is blanketed with intricate scenes drawn from vernacular romance literature of the Middle Ages, bringing to life a world of vivid characters. With every whisker and curl in place, armored knights and elegant ladies play out episodes in narratives revolving around the concept of love.

Beginning in the twelfth century, western Europe saw the rise of a secular literature centered on heroes. In the next century and beyond, courtly prose and poetry took up themes of love and manners, knights and adventure. Written in the languages people spoke, rather than the Latin still exclusively used by the church, the stories were the popular culture of the time, widely known by the aristocracy. Their protagonists could be easily recognized and narratives recalled in highly abbreviated representations, just as biblical iconography provided a visual shorthand for complex stories from the Old and New Testaments. This piece, a little smaller than a box of tissues, references so many distinct tales (only some of which are recounted here) that it seems to have been a kind of memory aid, helping the owner to recall highlights of some favorite minstrel's performance.

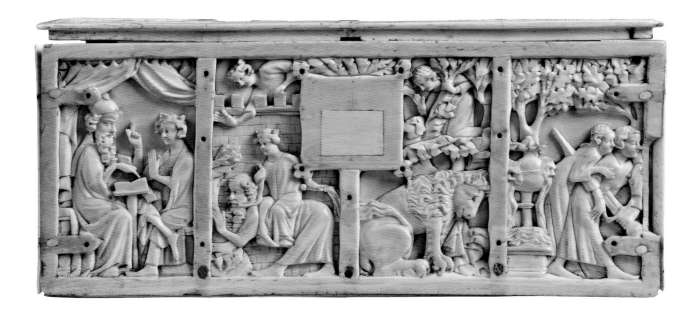

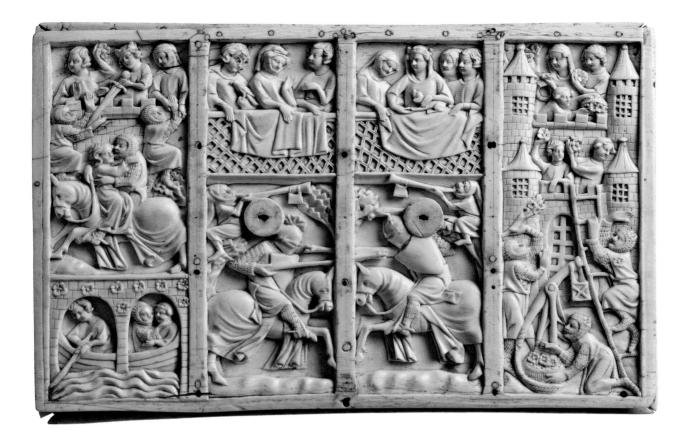

The casket's front is divided into four sections, with a blank square in the center where the lock plate once stood. On the far left, the bearded scholar Aristotle teaches the young prince Alexander the Great. The next section encapsulates a humorous legend about the great Greek philosopher, who had urged his pupil to avoid the distraction of love, to the annoyance of Phyllis, Alexander's paramour. In revenge, she seduced Aristotle and humiliated him by riding him like a horse. In the ivory, Phyllis is shown astride Aristotle, complete with bridle and whip, while Alexander spies on them from the top of a wall. The next two panels reduce the story of Pyramis and Thisbe to its essentials. This tragic tale from Ovid's *Metamorphoses* was retold throughout the Middle Ages. In the panel just to the right of center, Thisbe is up in the branches of a tree, having been frightened by the lion below, who tears her veil with his bloody mouth. Upon finding her bloodied veil, Pyramis wrongly assumes his love is dead and kills himself. When Thisbe discovers his body, she kills herself in turn. The artist of the casket has compressed the account, impaling the lovers together in a final embrace.

The lid of the casket has the most extensive area for carving and the liveliest scenes. In the two lower central panels, a tournament is taking place, with two armored knights tilting against one another. As they lean in with fierce concentration, their caparisoned horses charge while heralds blow horns. On a balcony above stand the joust's spectators, exactly the type of aristocrats with whom these stories were popular and for whom the casket was carved. The lid's two side panels show another romantic theme, the Assault on the Castle of Love. The charge is led by knights who seek to scale the ramparts on the left panel and operate a large catapult on the right. Both the attacking knights and the ladies who defend the besieged fortress are armed with roses, the flower of submission. There is no single known literary source, although the *Roman de la Rose*, a famous medieval love poem, could have influenced the use of roses as mock ammunition. The Assault on the Castle of Love, an allegory for the conquest of maidenhood by manhood, perfectly illustrates the use of romantic imagery in secular works of art of the late medieval period.

Ewer with Wild Man Finial

German, Franconia, probably Nuremberg, ca. 1500
Gilded silver, enamel, and paint, 25 x 8¼ in. (63.5 x 21 cm)
The Cloisters Collection, 1953 (53.20.2)

The mythological creature called the Wild Man is a distinctive figure in secular art of the later Middle Ages. Believed to have superhuman strength, he demonstrates his power brandishing his trademark club and holding a shield atop this gilded ewer, a display piece that also functioned as a vessel. Literary sources from the thirteenth through the sixteenth century, drawing upon ancient texts about monstrous races, describe the Wild Man's uncouth ways and primitive nature. A pelt of hair covers his body but leaves his face, hands, and feet bare. A denizen of the woods, the Wild Man represents everything beyond the realm of civilization; he is utterly ignorant of God and the salvation of the church.

On this ewer, the hair seems to have worn off the Wild Man's elbows and knees. Often black in other representations, the body hair is here a vibrant shade of green, finely detailed with curly ends; curls also finish his brown hair, moustache, and beard. His face has ruddy cheeks and a focused gaze. He wears a belt of twisted vines or branches and upon his head a wreath. He takes a strong, defensive position upon a miniature fortress with barred windows, crenellations, and buttresses adorned with statues; beneath it springs the dragon that forms the handle of the vessel, an elegant figure with fearsome claws, an arched back, and a twisted lock of hair on the top of its head. This Wild Man is protecting the castle from the dragon's attack.

In contrast, the Wild Man in a scene (fig. 24) on the ivory casket just discussed (entry 35) is a terrifying abductor who grasps an innocent maiden, who pleads to a mounted knight to rescue her. The armored knight, on a galloping horse, responds by impaling the Wild Man through the mouth with his lance. The scene exemplifies a trope of courtly love literature, the dashing knight who saves a lady from a monster.

Figure 24. Knight Rescuing a Maiden from the Wild Man, detail from Casket with Scenes from Romances (see entry 35)

The Wild Man on the ivory is a lustful and dangerous brute. The one on the ewer, made almost two hundred years later, is a protective strongman, demonstrating the figure's evolving character and meaning. In both cases, he is a savage or uncivilized creature of great strength, but at the time the ivory was made, the state of nature he embodies was viewed with distrust and fear. The ewer was the product of a later, more urban culture that viewed the state of nature with a benign nostalgia and the Wild Man as a guardian of civilization. The shield he holds once displayed a coat of arms identifying the ewer's owner, signifying the Wild Man's service as a defender of those arms, that owner, this ewer. The natural man-beast has by the sixteenth century been domesticated to protect the secular world of the castle.

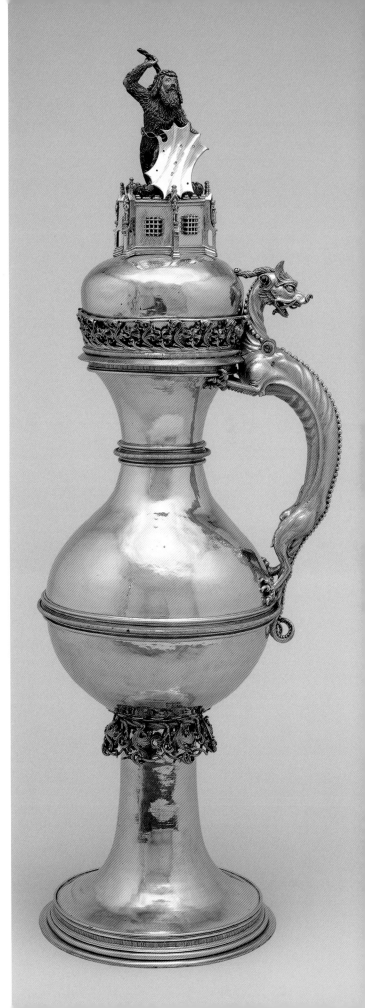

Corbel with a Pair of Beard-Pulling Acrobats

French, Aquitaine, ca. 1150–1200
Limestone, 32 x 15¼ x 18 in. (81.3 x 38.6 x 45.7 cm)
Gift of George Blumenthal, 1934 (34.21.1)

Madcap figures that appear to have nothing to do with theology scamper around the fringes of medieval art, whether painted in the margins of a manuscript or carved in stone, like this corbel. These dynamic images, which seem to have no purpose but to delight, can be categorized as marginalia.

This corbel (a bracket, or supporting element) is one of a suite that originally marked out the roofline of a monastery church, high up on the exterior and too distant to see easily. In this example, two entwined naked figures are pulling each other's beards. One is upside down, as if they were acrobats doing double somersaults together. The one on top bares his teeth in a grimace, while the other holds his mouth in a wide O of surprise. They are jongleurs, jesters, the irreverent entertainers of the time, although their representation here is not meant to be either specific or realistic. Such figures have no fixed theological connotation; rather, they have more generalized meaning as creatures of the world of disorder, outside the order of the church but very much part of life. Their position on the exterior of the church excused them from adhering to strict roles in the Christian narrative.

In the Romanesque period, fanciful figures like these were also sometimes found inside the monastery. The great French abbot and theologian Saint Bernard of Clairvaux (1090–1153) took issue with the practice of including nondoctrinal figures in sacred spaces: "But in the cloister, under the eyes of the Brethren who read there, what profit is there in those ridiculous monsters, in the marvelous and deformed comeliness, that comely deformity?" Yet marginalia are not entirely meaningless, even when they are not part of a canonical religious program. In another letter, Bernard compared himself and his monastic order, the Cistercians, to jongleurs, acrobats of the spirit who turn upside down the values of worldly and materialistic people. That is not to say that this corbel represents monks

as spiritual acrobats but rather that secular imagery could serve a religious metaphor. The pulling of beards is a motif that can refer to conflict, or the sin of Discord. Again, that doesn't limit this corbel to a strict single meaning but suggests layers of possible interpretation.

Similarly whimsical figures drawn from both real life and imagination frolic in the margins of manuscripts such as the Hours of Jeanne d'Evreux (entry 5). The diminutive prayer book contains an extraordinary compendium of drolleries, fanciful marginal images. Close to seven hundred drolleries depict the bishops, beggars, street dancers, maidens, and musicians that peopled the streets of medieval Paris, as well as apes, rabbits, dogs, and creatures of sheer invention. One fellow sits on the edge of folio 176r looking exasperated as the eagle perched on his shoulders pulls at his hair (fig. 25). The three figures on folio 22r (fig. 26) give further indication of the drolleries' skillful

Figure 25. Jean Pucelle. Marginalia (detail of fol. 176r), The Hours of Jeanne d'Evreux, Queen of France (see entry 5)

Figure 26. Jean Pucelle. Marginalia (detail of fol. 22r), The Hours of Jeanne d'Evreux, Queen of France (see entry 5)

execution, wit, and variety. A wild-haired youth, his rear quarters morphed into those of a lion, energetically rings hand bells. A floppy-eared dog chews a long bone, oblivious to the observant hare behind him. A goat with human arms plays on a huge jawbone as if it were a violin, using a rake as his bow. Like the corbel figures, these are primarily the fruit of the artist's imagination, not part of the structured iconography of the church, but some of the marginalia in the same manuscript do serve a theological program. For example, on folio 69r (see page 37), the animated figures beneath the Adoration of the Magi portray the Massacre of the Innocents. Here, King Herod, upon learning from the Magi that a child was born king of the Jews, orders the murder of male infants; a mother desperately tries to stop a man from killing her baby. Warning of this slaughter caused Joseph to flee with Mary and the newborn Jesus to Egypt (fol. 83r; see page 39). (See also the discussion in entry 5 of the drawings at the bottom of fol. 83r.)

In sum, it is hard to "read" marginalia definitively. As in art of the present day, medieval art may juxtapose high and low. Marginalia can carry a message or be purely playful. In this liminal world, meaning can be elusive but is not necessarily absent.

The Unicorn Tapestries

South Netherlandish, ca. 1495–1505
Wool warp with wool, silk, silver, and gilded wefts; The Unicorn Purifies Water: 12 ft. 1 in. x 12 ft. 5 in. (3.7 x
3.8 m); The Unicorn in Captivity: 12 ft. ⅞ in. x 8 ft. 3 in. (3.7 x 2.5 m)
Gift of John D. Rockefeller Jr., 1937 (37.80.2, .6)

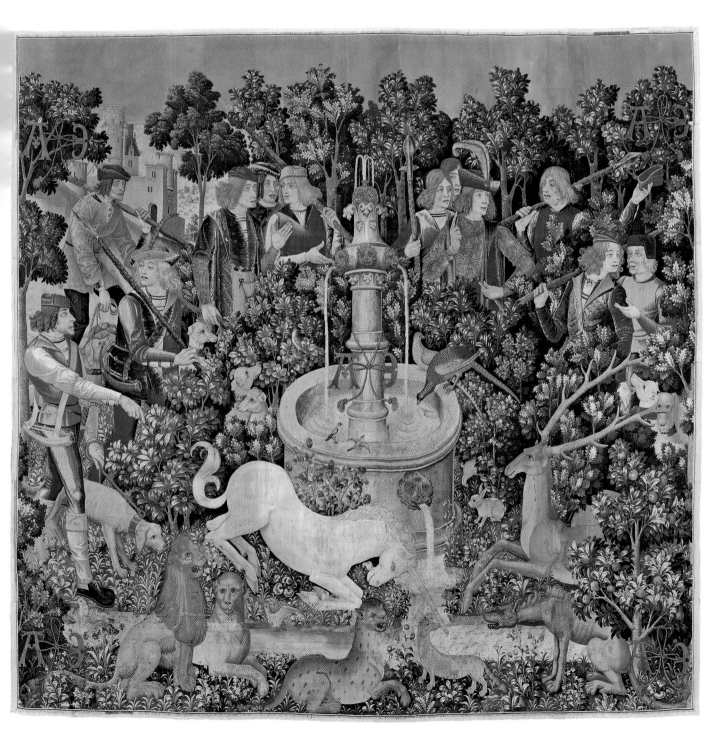

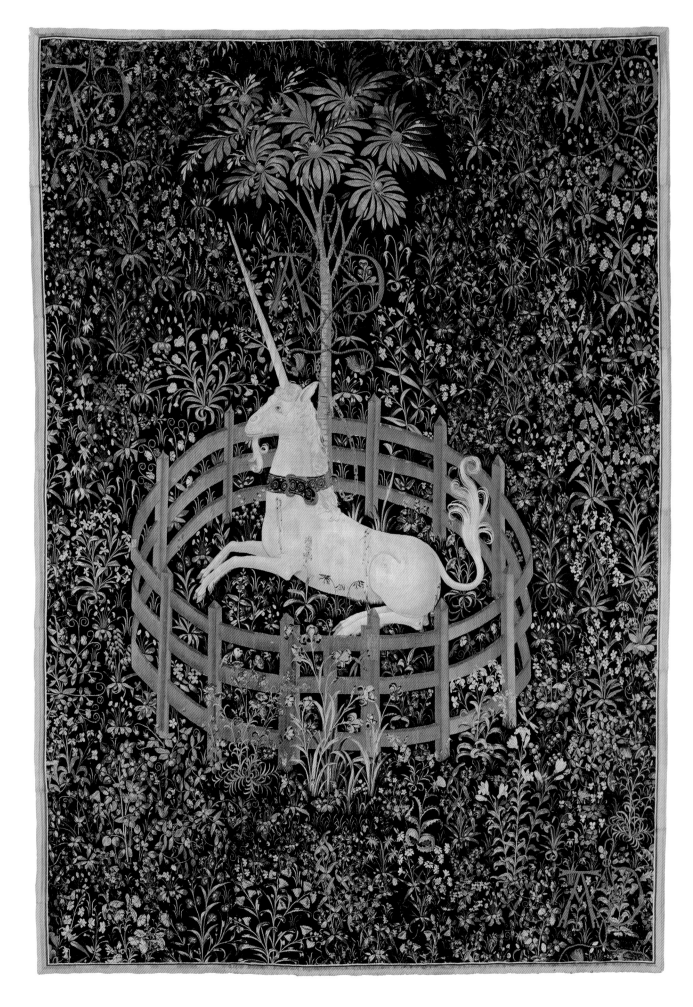

The mythical one-horned beast called the unicorn figured in the ancient literature of many cultures but was especially beloved in Europe during the later Middle Ages. As in these extraordinary tapestries, it is usually shown as a beautiful white horse but with cloven hooves, a beard, and a long, spiraling horn.

The Unicorn Tapestries at The Met Cloisters include six magnificent panels (two of which are illustrated and discussed here) and two fragments; they were assembled from more than one original set. Most of the scenes concern the hunt of the unicorn, presented as an exciting chase and capture akin to the aristocratic sport of stag hunting. Each of the tapestries is full of captivating detail, including realistically rendered flora and fauna. In the panel called the Unicorn Purifies Water (page 129), the beast kneels before a fountain, magically cleansing its stream with one touch of its horn. Other animals, including carnivorous lions as well as timid rabbits, gather around peaceably as the purification ritual takes place. Hunters watch and point to the unicorn but hold off their attack. Their detailed attire and hunting paraphernalia, including varied hats and vests, horns, spears, and collared dogs, reflect the style of contemporary aristocratic hunting. The hunt fiercely rages in the following tapestry panels.

The legendary way to capture a unicorn is better illustrated by a scene (fig. 27) from the previously discussed ivory casket (entry 35) than by surviving elements in The Cloisters tapestry set. There is only one way to catch a unicorn, according to the *Physiologus*, an ancient text that was the basis of medieval bestiaries: if a pure maiden sits in the forest, the unicorn will come to her and lay his head in her lap; at that moment he can be killed or captured. The line between secular and religious blurs in this element of the myth. While the virgin's role had a secular origin in the *Physiologus*, capture by a virgin has Christological reverberations. Because God was "captured" by the Virgin in the incarnation, becoming man, the unicorn was interpreted as a symbol of Jesus in medieval Christian bestiaries.

The tapestries' hunt sequence ends with the murder of the unicorn and the delivery of his pathetic figure to a richly attired lord and lady, inviting a comparison with the Deposition. The final panel, the Unicorn in Captivity (opposite), is not from the hunt set and may have been

Figure 27. Capture of the Unicorn, detail from Casket with Scenes from Romances (see entry 35)

made as a single tapestry. Like the others, however, it prominently features the letters AE, referring to the unknown original owner. The unicorn, collared and enclosed by a fence, lies under a tree in a field of flowers. The overall pattern is called millefleurs (thousand flowers), an important late medieval decorative motif featuring botanically accurate imagery. This panel can be read as the unicorn's resurrection after a poignant death, in accordance with the identification of the gentle beast with Jesus. But an alternative interpretation comes from vernacular love poetry, in which the unicorn represents the Beloved Tamed. The fence shown in the tapestry is not high enough to prevent his escape: the lover willingly submits to the thrall of his mistress. In this reading, the red drops on the unicorn's back are to be understood not as blood but as juice bursting from the pomegranate tree above, its heavily seeded fruit a symbol of fertility and marriage. Recent research suggests another interpretation, in which the unicorn might stand for one side in a political dispute and battle of the period.

Apart from any underlying meanings to be discerned, these wonderful weavings of wool, silk, and precious metallic threads reward hours of study of their closely observed details. They also serve as a reminder that, for the medieval mind, even the secular echoes with stories and mythologies both pagan and Christian, and nothing is ever far from God.

Suggested Reading

For information about objects in the Metropolitan Museum's medieval collection, an invaluable resource is the Museum's website, www.metmuseum.org. Further information on individual works in this book can be found by searching the site by the object's accession number. Thematic discussions of medieval art can be found on the website's *Timeline of Art History*.

Apostolos-Cappadona, Diane. *Dictionary of Christian Art.* New York: Continuum, 1994.

Bagnoli, Martina, et al. *Treasures of Heaven: Saints, Relics, and Devotion in Medieval Europe.* Exh. cat. New Haven, Conn.: Yale University Press, 2010.

Barnet, Peter, and Nancy Wu. *The Cloisters: Medieval Art and Architecture.* Rev. ed. 2005; New York: The Metropolitan Museum of Art, 2012.

Belting, Hans. *Likeness and Presence: A History of the Image before the Era of Art.* Translated by Edmund Jephcott. Chicago: University of Chicago Press, 1994.

Camille, Michael. *Image on the Edge: The Margins of Medieval Art.* London: Reaktion Books, 1992.

———. *Gothic Art: Glorious Visions.* New York: Harry N. Abrams, 1996.

Cavallo, Adolfo Salvatore. *The Unicorn Tapestries at The Metropolitan Museum of Art.* New York: The Metropolitan Museum of Art and Harry N. Abrams, 1998.

Cormack, Robin. *Byzantine Art.* Oxford History of Art. Oxford: Oxford University Press, 2000.

Diebold, William J. *Word and Image: An Introduction to Early Medieval Art.* Boulder, Colo.: Westview, 2000.

Evans, Helen C., Melanie Holcomb, and Robert Hallman. "The Arts of Byzantium." *Metropolitan Museum of Art Bulletin*, n.s., 58, no. 4 (Spring 2001).

Evans, Helen C., and William D. Wixom, eds. *The Glory of Byzantium: Art and Culture of the Middle Byzantine Era, A.D. 843–1261.* Exh. cat. New York: The Metropolitan Museum of Art, 1997.

Fliegel, Stephen N. *A Higher Contemplation: Sacred Meaning in the Christian Art of the Middle Ages.* Kent, Ohio: Kent State University Press, 2012.

Forsyth, Ilene H. *The Throne of Wisdom: Wood Sculptures of the Madonna in Romanesque France.* Princeton, N.J.: Princeton University Press, 1972.

Gerson, Paula, general ed. *The Pilgrim's Guide to Santiago de Compostela: A Critical Edition.* 2 vols. London: Harvey Miller, 1998.

Giorgi, Rosa. *Saints in Art.* Translated by Thomas Michael Hartmann. Los Angeles: J. Paul Getty Museum, 2003.

Green, Rosalie B., ed., and Isa Ragusa, ed. and trans. *Meditations on the Life of Christ: An Illustrated Manuscript of the Fourteenth Century.* Princeton Monographs in Art and Archaeology. Princeton, N.J.: Princeton University Press, 1961.

The Holy Bible: Douay-Rheims Version. Charlotte, N.C.: Saint Benedict Press in association with Tan Books, 2009.

Husband, Timothy B. *The Art of Illumination: The Limbourg Brothers and the Belles Heures of Jean de France, Duc de Berry.* Exh. cat. New York: The Metropolitan Museum of Art, 2008.

Jacobus de Voragine. *The Golden Legend: Selections.* Selected and translated by Christopher Stace. London: Penguin, 1998.

Kessler, Herbert L. *Seeing Medieval Art.* Rethinking the Middle Ages, 1. Peterborough, Ont.: Broadview, 2004.

Lipton, Sara. "'The Sweet Lean of His Head': Writing about Looking at the Crucifix in the High Middle Ages." *Speculum* 80, no. 4 (Oct. 2005): 1172–1208.

———. *Dark Mirror: The Medieval Origins of Anti-Jewish Iconography.* New York: Metropolitan Books, Henry Holt, 2014.

Mathews, Thomas F. *Byzantium: From Antiquity to the Renaissance.* New Haven, Conn.: Yale University Press, 1998.

Murray, Peter and Linda. *A Dictionary of Christian Art.* Oxford: Oxford University Press, 2004. Online edition available by subscription: Murray, Peter and Linda, and Tom Devonshire Jones. *The Oxford Dictionary of Christian Art and Architecture.* Oxford: Oxford University Press, 2013.

Nees, Lawrence. *Early Medieval Art.* Oxford History of Art. Oxford: Oxford University Press, 2002.

Parker, Elizabeth C., and Charles T. Little. *The Cloisters Cross: Its Art and Meaning.* New York: The Metropolitan Museum of Art, 1994.

Sekules, Veronica. *Medieval Art.* Oxford History of Art. Oxford: Oxford University Press, 2001.

Warner, Marina. *Alone of All Her Sex: The Myth and the Cult of the Virgin Mary.* 2nd ed. 1976; Oxford: Oxford University Press, 2013.

Wieck, Roger S. *Time Sanctified: The Book of Hours in Medieval Art and Life.* Exh. cat. 2nd ed. 1988; New York: George Braziller, 2001.

Wixom, William D., ed. *Mirror of the Medieval World.* Exh. cat. New York: The Metropolitan Museum of Art, 1999.

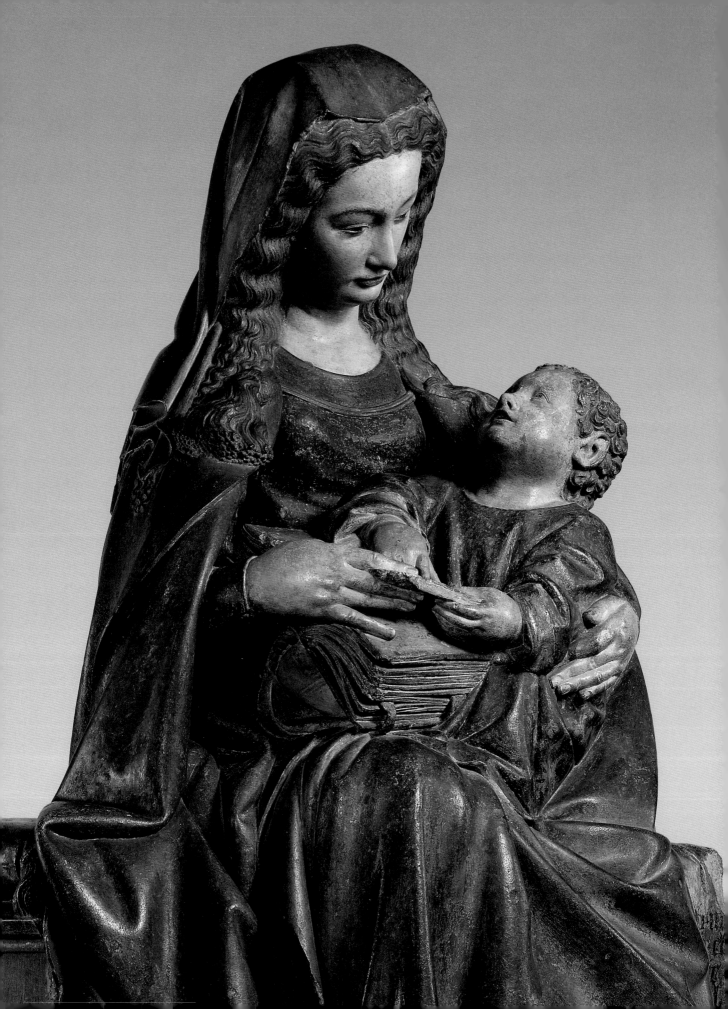

Acknowledgments

My thanks go first to the Department of Medieval Art and The Cloisters, which has provided me with a home in the Museum going back some forty years, and continuously for the last fifteen. Peter Barnet, Senior Curator, first endorsed me to write this book, affirmed by C. Griffith Mann, Michel David-Weill Curator in Charge. Both of them have generously reviewed several versions of the text, giving me valuable advice. Other curators in the Department offered me support in many ways, from warm encouragement, to reviewing the selection of objects, to vetting the entries, and for that I thank Barbara D. Boehm, Paul and Jill Ruddock Curator; Helen C. Evans, Mary and Michael Jaharis Curator of Byzantine Art; Melanie Holcomb; Timothy B. Husband; and Charles T. Little. Other departmental help was graciously given by Christine E. Brennan, Elizabeth Eisenberg, Hannah Korn, R. Theo Margelony, Christine D. McDermott, Thomas C. Vinton, and Andrew Winslow.

In the Publications and Editorial Department, Gwen Roginsky first encouraged me to write a volume for the How to Read series and has championed this book ever since. I am indebted to that Department for so much guidance. A number of individuals there contributed to the creation of this volume, including Mark Polizzotti, Michael Sittenfeld, Peter Antony, Anne Blood, Lauren Knighton, Megan Kincaid, and Elizabeth De Mase. Nancy E. Cohen truly rescued me and this book at a critical moment and was a sensitive and collegial editor. Thanks also to Rita Jules, the designer who brought many elements together to craft a beautiful book.

Peter Zeray took the wonderful new photographs, both in his studio and in galleries at The Met and The Met Cloisters. Julie Zeftel helped identify the best among existing images of objects illustrated here.

My sincere gratitude goes to the Mary C. and James W. Fosburgh Publications Fund, The Peter Jay Sharp Foundation, the Estate of Thomas Hoving, and The Levy Hermanos Foundation, Inc., for their generous support of this book.

My late mother first instilled in me a fascination with art. My lifetime interest in medieval art has always been centered on the ways that its storytelling sheds light on power and on spirituality. Many scholars formed my views on the Middle Ages, and I would like especially to acknowledge Robert Harris, Ilene Forsyth, Michael Camille, and Sara Lipton for insightful analysis.

Dear friends gave support during the process of researching and writing this book and always: Susan Buckley, Diane Englander, Jill Alberts, and Berniece Penner. Lauren Sanchez has been inspirational. Above all, my love and gratitude go to my family: my handsome, kind, and wise sons, Ben and Jacob Friedman, whose encouragement means so much; my daughter-in-law, Jacob's wife, the incandescent Isabel Parkes; and especially my irrepressible, fabulous husband, Bart Friedman, cheerleader in chief, love of my life.

Wendy A. Stein

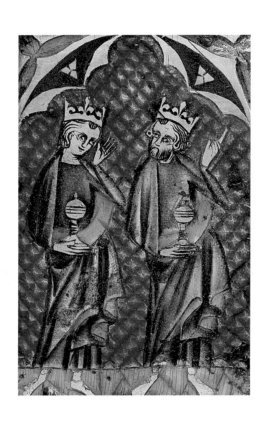